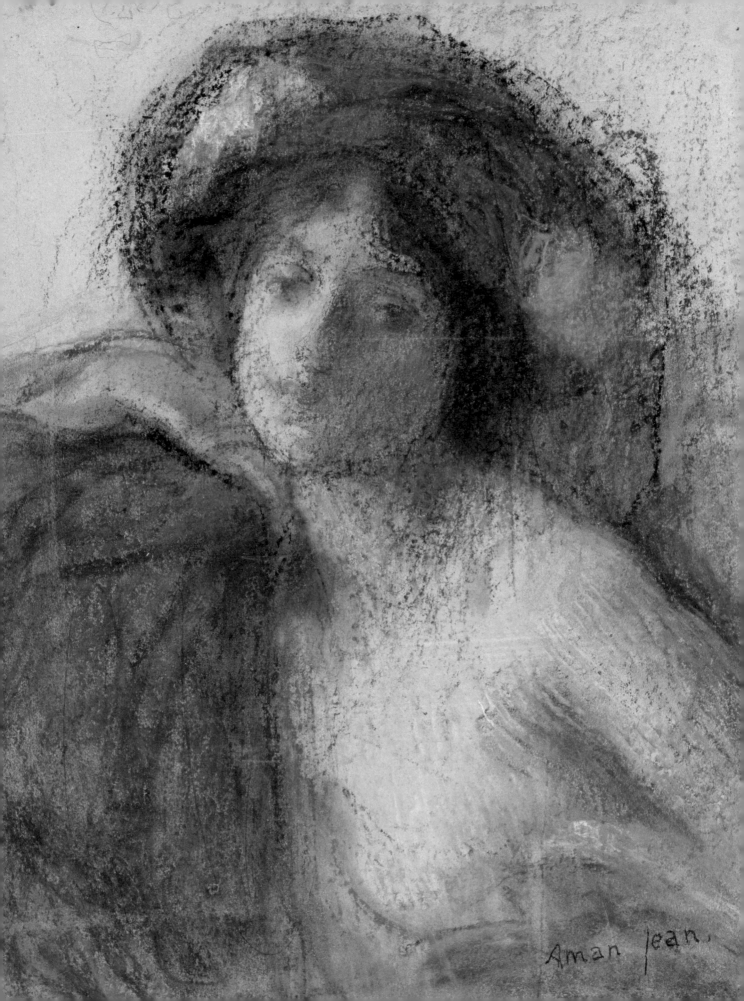

THE MODERN

Woman

DRAWINGS BY DEGAS, RENOIR, TOULOUSE-LAUTREC AND OTHER MASTERPIECES FROM THE MUSÉE D'ORSAY, PARIS

Exhibition Commissioners

Guy Cogeval, Président of the Musée d'Orsay; Isabelle Julia, Curator for the Musée d'Orsay; and Thomas Padon, Assistant Director and Director of International Partnerships for the Vancouver Art Gallery

Isabelle Julia, Curator

VANCOUVER ART GALLERY | MUSÉE D'ORSAY

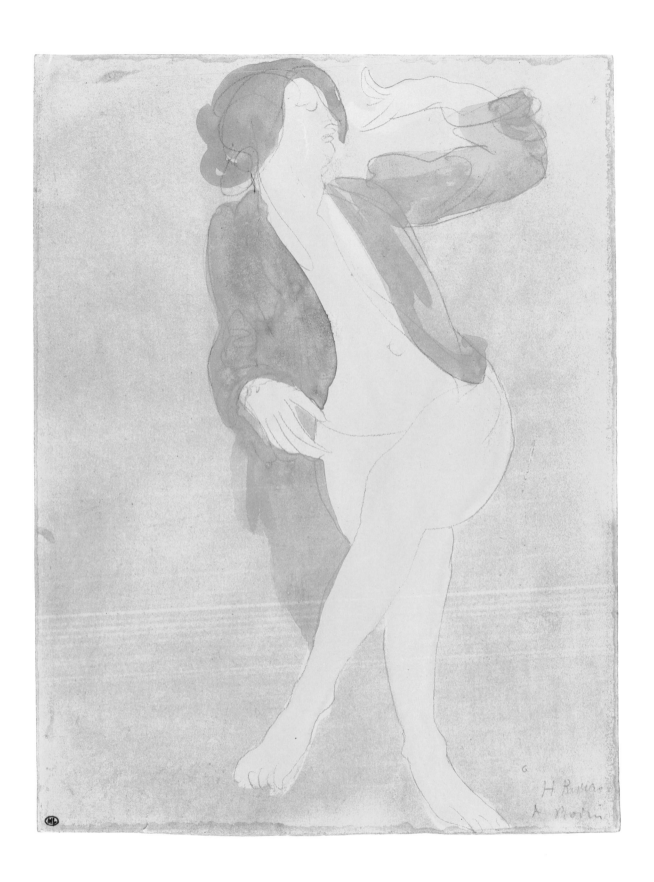

RODIN, Auguste *Nude Wearing a Brown Jacket / Femme nue, portent une veste brune* c. 1905

DIRECTORS' FOREWORD

Kathleen S. Bartels 7

Guy Cogeval 9

INTRODUCTION

Thomas Padon 11

IMAGINING THE MODERN WOMAN

Isabelle Julia 15

PLATES

The Portrait 38

The Nude 54

The Space of Intimacy 66

The Private Realm 78

The Public Realm 94

Beyond the City 110

LIST OF WORKS 127

ACKNOWLEDGEMENTS 135

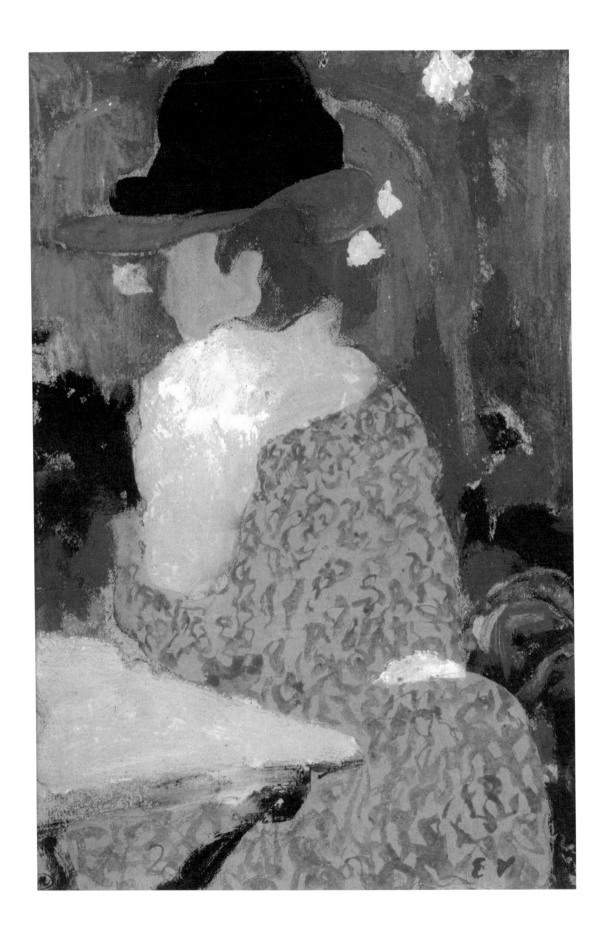

DIRECTORS' FOREWORD

Kathleen S. Bartels
Director, Vancouver Art Gallery

Modernity signifies the transitory, the fugitive, the contingent; it is one half of art, the other being the eternal and the immutable. — Charles Baudelaire

Drawings provide a spontaneous, visceral connection to the creative impulse. In works made by the brilliant group of artists who lived and worked in France during the 1800s — and who are represented in the exhibition *The Modern Women: Drawings by Degas, Renoir, Toulouse-Lautrec and Other Masterpieces from the Musée d'Orsay* — it is possible to glimpse the dramatic social and political changes underway in that country's particularly tumultuous century. It is also possible to discern a profoundly new approach to image-making. Beginning in the mid-nineteenth century, a large group including such well-known figures as Gustave Courbet and Honoré Daumier swept away centuries of artistic convention and began to capture scenes of everyday life. In their startlingly direct depictions of women, one of the most prevalent subjects, these celebrated artists captured a sense of the "modern." Through a selection of 97 extraordinary works, the exhibition not only constitutes a spectacular overview of draftsmanship by all of the celebrated artists of the *Belle Époque*, but also provides a fascinating look at the changing role of women during this dynamic era.

The Musée d'Orsay is without question the world's greatest repository of nineteenth-century French art. It is with particular pride, therefore, that we at the Vancouver Art Gallery have initiated this historic project, marking the first exhibition of drawings from the Musée's incomparable collection. I wish to express my gratitude to the Musée d'Orsay for its remarkable generosity in lending so many of its best works on the occasion of this exhibition. I also wish to express my appreciation for the expertise and collegiality of the many members of its staff who helped realize the exhibition. In particular I would like to recognize Guy Cogeval, Président du Musée d'Orsay, who responded so enthusiastically to our initial proposal for the exhibition and whose support throughout this project has been instrumental to its organization.

Isabelle Julia, Conservateur général du Patrimoine, Arts Graphiques, Musée d'Orsay, and the curator of this exhibition, deserves special recognition for her scholarship, imagination and

insight. Her vision for the project provides a fascinating glimpse into the changing role of women in nineteenth-century French art and the era's concept of modernity. The selection she made for the exhibition, assisted by Thomas Padon, Assistant Director / Director of International Partnerships here at the Gallery, and her essay in these pages poetically bring to the fore the artistic and intellectual milieu in which these drawings were made.

I am tremendously grateful to Maynards Industries for their generosity as the Presenting Sponsor of *The Modern Woman* and I offer my special thanks to its President and Gallery Trustee, Barry Scott. My great appreciation is given to Concord Pacific and its President, Terry Hui, for joining the Gallery as Major Sponsor of the exhibition. To Scotiabank, I extend my sincere thanks for their Supporting Sponsorship. As well, I offer my deepest gratitude to Gallery Trustee, Lesley Stowe, for her personal generosity and fundraising leadership, and to donors Joan Anderson, Debra Lykkemark of Culinary Capers Catering, and Faith Wilson. The exhibition is also supported by the Canadian Travelling Exhibitions Indemnification Program of the Department of Canadian Heritage.

I wish to thank the Board of Trustees of the Vancouver Art Gallery for its unwavering support and enthusiasm for *The Modern Woman*, led by Board Chair David Aisenstat. To the talented and dedicated staff at the Gallery, I extend my gratitude for bringing this project to fruition. Special thanks are due to Thomas Padon, who initiated the discussions that led to the development of the project and has been instrumental in its organization. As well, his contribution to the catalogue provides a rich context to this extraordinary group of drawings.

The Vancouver Art Gallery is committed to collaborating with our museum colleagues internationally to bring outstanding works of art to this city. We are delighted to present — in this historic exhibition with the intriguing subject of women as its focus — this marvelous overview of the glories of draftsmanship in one of the most acclaimed periods of French art.

Guy Cogeval

Président du Musée d'Orsay

For the first time since its inception, the Musée d'Orsay has collaborated with another institution, the Vancouver Art Gallery, to develop an exhibition drawn from Orsay's extraordinary collection of drawings. It has been a particular pleasure to work on this project with our esteemed colleagues in Vancouver under the skillful direction of Kathleen Bartels. The Musée d'Orsay's multidisciplinary collection covers the second half of the nineteenth century and the beginning of the twentieth, and among its most notable glories are its many indisputable masterworks of French drawing. That a grouping as coherent as the one presented here—which gathers together such renowned but diverse artists as Courbet, Degas, Manet, Toulouse-Lautrec and Bonnard—should be shown in a single exhibition is truly exceptional.

The theme of this exhibition, "the modern woman," has allowed us to depict women in every guise. In the period covered here, artists trained a new and multivalent gaze upon their female models, whose situation in the world was rapidly evolving. Until then, women had been portrayed in art primarily as goddesses or saints; but beginning in the mid-nineteenth century, the artists' viewpoint began to change, and their subject became real women. These artists concentrated particularly on women in large cities, young or old, aristocratic or working-class, but also portrayed women from the countryside. They rendered scenes of daily life, in a hazy timelessness or in the harsh light of modernity; sometimes they reached around the world, as with Gauguin's depictions of Tahiti and the Marquesas Islands.

The many different techniques used in these drawings—pen and ink, pencil, wash, watercolour, red chalk—bespeak an unfettered approach to expression, practice, and experimentation on the part of painters and sculptors; some of these works, precious pastels, are so fragile that they are leaving Paris and the Musée d'Orsay for the first time. Thus, this exhibition marks a truly historic occasion.

All the artists represented here, the known and the less known, are bound together by close friendship and a shared æsthetic, developed over fervent debates at Paris cafés, at group shows (whether at dealers' shops or at the private galleries that were then beginning to emerge), during stays at each others' country properties, at the country homes of collectors and patrons, or while travelling together.

This project is the result of our express desire to further the extraordinary cultural exchange that we have long enjoyed with Canada.

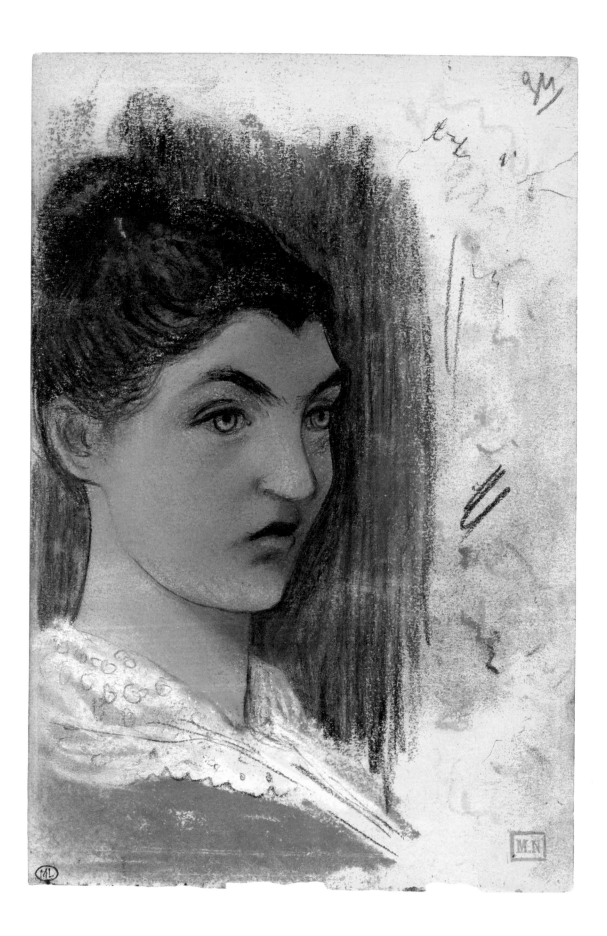

INTRODUCTION

Thomas Padon

When in 1852 Napoléon III was crowned Emperor in Paris, France had endured over fifty years of political, social and economic upheaval. No less than six French regimes had succeeded each other since the beginning of the nineteenth century, alternating between monarchical and republican rule and accompanied by shifting allegiances and considerable intrigue. Prompted by the Second Republic National Assembly's refusal to amend the constitution so he could serve for a second term as President, Napoléon III (nephew of Napoléon Bonaparte) seized the government in a coup d'état and claimed dictatorial powers, launching the Second Empire. It would prove to be a relatively peaceful eighteen-year interlude in an otherwise tumultuous century. As it had been for his royal predecessors and his uncle, Paris became for Napoléon III the physical embodiment of dynastic power and the template on which he would create a fitting capital for his new empire.

Having spent part of his youth in England, Napoléon III had seen first hand the economic potential of industrialization and, as Emperor, he sought to remake France's economy from a largely agrarian model. Tariff reform, an active stock market, the founding of new banks, the mining of natural resources and the inauguration of an extensive railway system led to a substantial increase in production and trade, creating an economic powerhouse second only to England. Amidst this feverish activity, people flocked to Paris. Its population doubled between 1800 and 1850, approaching a million inhabitants; it would double again in less than 25 years and exceed 2.5 million by the close of the century.

The most enduring legacy of the Second Empire is undoubtedly the physical remaking of Paris, one of the boldest experiments in urban planning. Appointed in 1853 by Napoléon III as prefect of the Seine (there was no office of mayor at the time), Baron George-Eugène Haussmann undertook nothing less than a complete rethinking of the requirements of a modern city. Streets were paved and lit by gaslight (hence the city's early nickname "the city of light"); manufacturing was relocated from the historic centre to newly planned areas on the city's periphery; sewer and water supply networks were built; 100,000 trees were planted; and large new parks and small public squares were established. More complex was Haussmann's herculean undertaking to create

grand boulevards radiating out from the city's centre, giving Paris the elegant appearance it retains today. Even beyond its staggering cost, Haussmann's vision for Paris came at a high price: the city was inconvenienced for decades by massive construction and almost 400,000 citizens were dislocated, a disproportionate number of these from poorer neighbourhoods. Yet the economic stimulus of this project had the desired effect: it employed a fifth of the Second Empire's Parisian workforce in construction activities, created speculative real estate development of the grand, but uniform, apartment buildings that lined the new boulevards, and transformed the demographic cast of the city by attracting thousands of new middle-class residents and small businesses to the heart of Paris. Haussmann had brought light, air and grand vistas to a city formerly known for its dark warrens of small streets. Although controversial within Paris, his efforts were soon lauded beyond the city's borders, and there was an immediate influx of tourists, especially for the four world fairs held during the second half of the century. For good reason, Victor Hugo considered Paris "the focal point of civilization," and Balzac thought of it as "the head of the world, a brain exploding with genius." The city was a febrile centre of creativity, home in this period to writers Balzac, Dumas, Flaubert and Zola; poets Baudelaire, Mallarmé and Rimbaud; artists Daguerre, Degas, Manet, Nadar and Renoir; composers Bizet, Gounod, Massenet and Offenbach; and architects Garnier and Labrouste and the engineer Eiffel. In addition, successive governments had provided lavish funding for educational and scientific institutions, and Paris became the preeminent centre of research and book production.

In this dynamic milieu, and echoing the Realist literature of Balzac and Flaubert, a number of artists in Paris began to turn to scenes of contemporary life for their subject matter. The Académie de peinture et de sculpture had been founded in 1648 and it tightly governed not only schooling for artists, but also the annual exhibitions that were the primary means by which their work could be seen. Artists included in *The Modern Woman* such as Daumier, Manet and later Degas gradually turned away from the formal—and, they felt, contrived—portraits, landscapes and historical scenes that had been sanctioned by the Académie and, as such, had dominated French art for centuries. This was not a clean break, however; artists such as Millet and Manet would continue to show at the Académie's annual Salon, exhibiting challenging works, many of which became a *succès de scandale*.

Although the Académie remained formidable, its influence was on the wane. Beginning in the 1870s, many artists showed their work in alternative exhibitions (including the 1874 exhibition from which the term Impressionism arose) that were an affront to the Académie's hegemony. These independent venues would proliferate as the century progressed. Women remained a prominent subject in art; however, as Isabelle Julia astutely relates in the following text, some artists

whose work is assembled in these pages took a new approach to their subject. Gone were the historicizing tropes that had bestowed legitimacy on the nude female figure. As the drawings in this book evince, the artists now displayed an astonishingly direct connection to their subjects. These were not idealized figures; they were real women, most of whom lived in Paris, walking the very streets created by Haussmann and encountering there the riotous mix of society that had become known as *le tout Paris*. Artists and authors alike celebrated the exhilarating, non-hierarchical experience of contemporary city life, with people of different classes coming into contact with each other as never before in the streets, department stores (a recent invention), theatres and cafés that flourished during this era. The drawings in *The Modern Woman* provide an intimate view of women as they went about their daily lives, seemingly unaware of the artists' presence.

Surprisingly, despite the radical overhaul of Paris into a modern city and the otherwise progressive domestic policies of Napoléon III, the legal rights of women advanced little during the Second Empire and the period immediately following. Indeed, although women had played a key role in the events leading up to the French Revolution, they were quickly relegated to the political margins. It was perhaps the very unpredictability of the Revolution and the ensuing Reign of Terror that led to mistrust — even amongst many social reformers — of any ideology other than that encouraging traditional matriarchal roles for women. Some saw *any* expanded public role for or legal standing of women as having the potential to undermine not only the family, but the very fabric of the French state.

Even if legal equality was not forthcoming in France (women were not granted voting rights until 1944), women were ascendant in the last half of the nineteenth century. There were fascinating and passionate debates about the role of women led by figures such as Ernest Legouvé and Eugénie Niboyet, the latter boldly founding *Voix des femmes*, a political newspaper unabashedly advancing the cause of women in education, in the workforce, in law and within the sphere of the home. Unfortunately Niboyet's voice, and political dissent generally on behalf of women's rights, was stifled amidst the conservative tide that rose in the Second Republic and then Empire.

Despite legal parity in the last half of the nineteenth century, women nevertheless enjoyed unprecedented social independence. Looking at the women depicted in these pages from today's perspective, one is struck by their remarkable degree of self-assurance and freedom, whether it be to enjoy leisure time activities in solitude or with female friends (men are often noticeably absent in these drawings) or to pursue a profession. Almost as the *flâneur* whom Baudelaire brilliantly captured in his writing, the artists who created these drawings provide an intimate look into the lives of women who were part of the extraordinary, transformative era called the *Belle Époque*.

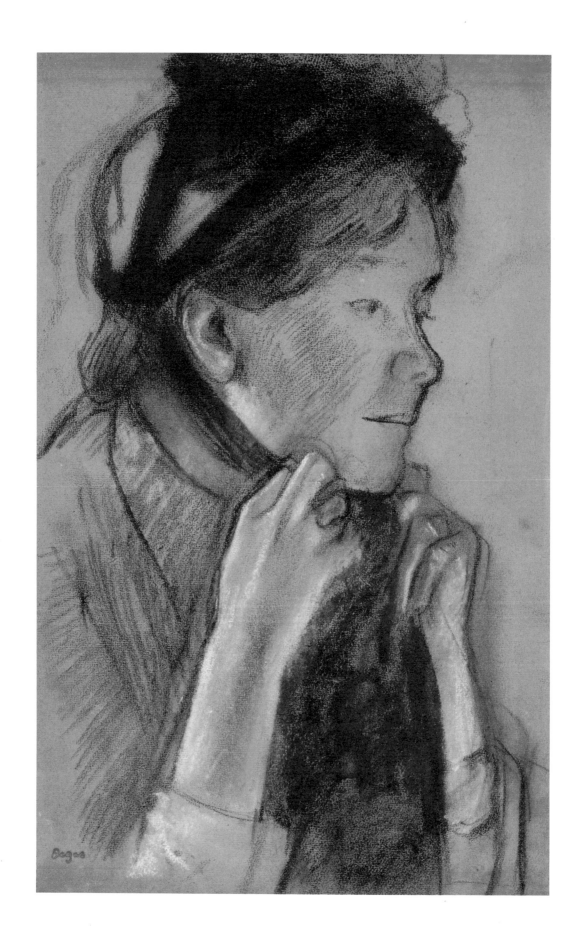

IMAGINING THE MODERN WOMAN

Isabelle Julia

LOVE LINES

Pliny the Elder relates that the maiden Dibutade, faced with her lover's departure, traced the profile of the boy's shadow on a wall with a piece of charcoal, thereby introducing the art of drawing to Greece. Love invented the pencil stroke to hold onto a shadow, or so they say. Others report that a prince fell in love from gazing at a portrait. Which came first, drawing or love? The two emerged together, of course, inseparable as the body and its reflection, as the line and the paper supporting it. We love while drawing and draw while loving. To look at women and girls in their various states of being means to draw them for the sake of love, for love of the body and of drawing, for love of the fleeting shadow that the hand tries to hold back. To draw already means to love.

HEAVEN ON EARTH

From Antiquity to Delacroix, what do women represent in art? Essentially goddesses and princesses, as in written tragedies (*Ut pictura poesis*). They are celestial bodies, principles of beauty. Beauty is the object of art; woman is beauty — which leads to Venus, which leads to artists portraying Venus. *Venus Anadyomene*: from the sea's foam, beauty and love arise. There is nothing real about this. We mustn't forget that the point of all classical art is to *imitate nature* — in other words, to depict divine creation in its supra-celestial essence: Beauty is the ideal of what is beautiful. The harsh triviality of Realism, as in Rembrandt's peeing women, is merely the exception that proves the rule. Goddesses and princesses, beauties who are more than beautiful: the female body is the essence of Beauty, which is all these artists really care about. *All* of them, for centuries, and despite their æsthetic quarrels, saw eye to eye on this point.

But in the nineteenth century everything changed. The classical universe was religious, controlled, abstract. The nineteenth century, on the other hand, gave itself over to a permanent quest, as people succumbed to the infinite and enticing diversity of a mythical Elsewhere,

DEGAS, Edgar *Woman (Mary Cassatt) Tying the Ribbons of Her Hat /*
Femme nouant les rubans de son chapeau, Mary Cassatt c.1882

a restless desire to be always other than where one *is*. The Second Empire (1852–1870) would see the birth of an innovative spirit, which affected everyone and which came to be called modernity. The concept spread through life and the arts — whether literature, theatre, music, painting or, especially, drawing.

At the end of the eighteenth century, during Romanticism's first stirrings and well before Nietzsche, the German writer Jean Paul Richter announced: "There is no God! ... We are all orphans, I and you: we are without Father!" Then heaven will descend to earth, nature will become reality, beauty will no longer be what it was — and the goddesses and princesses will awake as ordinary women. They will appear nude or clothed, beautiful or ugly, young or old, sitting or standing or in no particular pose, as housewives or prostitutes, *as they are*, in the perpetual motion of daily life that the artist attempts to capture. We encounter so many drawings of women in the second half of the nineteenth century: mothers, lovers, courtesans, victims, redeemers, triumphant heroines, femmes fatales, socialites, factory girls, women of easy virtue, Parisians or provincials, city women and country maids, embodiments of national virtues or of debauchery ... Charles Baudelaire's lapidary phrase, "Anywhere out of the world" (*Paris Spleen*), with its call to an endless voyage, expressed the deepest aspirations of Romanticism. One could say that the depiction of woman, in all her facets, was the embodiment of these new aspirations — resulting in an unprecedented proliferation of images.

DRAWING: INTIMATE EXPRESSION OF THE ARTIST'S INDIVIDUALITY

Ingres' advice to the young Edgar Degas —"Draw lines ... many lines, from memory or from life"— was taken up by a remarkable number of would-be artists. The increase in the popularity of drawing might be a function of the medium's various techniques: so eclectic, supple, spontaneous — and sometimes so crude. Or of the range of materials one might use, whether pencil, pen or brush; or of the effects produced by the subtle interplay between the paper tints and the pigments (ink, watercolour, gouache, red chalk, charcoal, pastel...). In addition, and more than ever before, drawing proved a considerable means of subsistence for struggling artists, owing to an upsurge in sales through dealers such as Durand-Ruel, Boussod et Valadon, and Vollard. Moreover, the medium embraced a wide variety of subjects and approaches — from quick sketches made from life or executed from memory back at the studio to polished works intended for a collector's salon.

We can also explain this proliferation by the new status conferred upon drawing, which went from being just an academic exercise or way of preserving a subject for large-scale compositions to a full-fledged expression of the modern age. The aim of drawing stopped being to explore

the world's forms and became instead to reflect them "faithfully," but *as seen through the lens of a particular temperament.* It offered a wide range of visual possibilities that called upon the artist's intellect, sensitivity and desire for freedom. Rather than looking to discover the essence beneath appearances, the artist now sought out emotions and ideas that spoke to the personality not only of the subject but also of the individual creating the work. To draw is to make manifest the deep inner self that allows one to grasp an object in all its permutations. As Paul Valéry wrote in 1938, referring to Degas, "Drawing is not form, but a way of seeing form."

Social and æsthetic revolutions, succeeding each other throughout the nineteenth century at an increasingly frenetic pace, drew artists into an ideological and formal quest. The ways in which women were portrayed can be underscored as a particularly meaningful, rich and varied aspect of this quest.

The body's beauty is a gift sublime
That wrests forgiveness for the basest crime
— Baudelaire, "Allegory"

Among the first nudes shown in the present exhibition is a work by Jean-François Millet, an artist rarely mentioned in connection with full, frank renderings of the model's unclothed body (p. 58). In the privacy of his studio, Millet posed a robust young woman, probably for a now lost painting of a nymph. She exhibits a proud torso plainly offered to our gaze, and her face betrays a serious and tragic awareness of love. In Baudelaire's words, "[Woman] is a divinity, a star … a glittering conglomeration of all the graces of Nature, condensed into a single being" ("The Painter of Modern Life").

It was only in the middle of the nineteenth century that women were allowed to pose nude before groups of young art students. Fantin-Latour's *Truth* (p. 57) neatly expresses this evolution: its title underscores the significance of the scene, as do the many changes of heart revealed by Fantin's preparatory studies from the year 1864. This allegory is something of a mission statement for the Realist æsthetic. Truth, the woman's unclothed body, is the source of artistic inspiration for the writers, musicians and painters gathered there. The figure at the easel on the right is most likely Edouard Manet, a close friend of Fantin's.

Under the Second Empire and the Third Republic (1870–1940), Paris, seeking to affirm its place as capital of the modern world, was seized by a frenzy for erecting public buildings (town halls, courthouses, universities, theatres, operas…). Sighs Baudelaire:

Old Paris is no more (the city scape
Is quick to change: less so the human heart) ("The Swan")

The painters and sculptors commissioned to decorate these palaces of the Republic, temples to a new secular Gospel, found the work both stimulating and lucrative. Puvis de Chavannes, Luc-Olivier Merson, Antoine Bourdelle and Aristide Maillol were no doubt the most inventive, innovative and prolific of the lot. Republican virtues such as justice, charity, industry and agriculture were allegorically represented as female figures, displaying all the clichés of previous centuries but portrayed in the realist manner typical of the period.

In classic academic fashion, painters often made studies to help them position figures in large decorative compositions. Puvis de Chavannes' *Nude Seen from Behind* (p. 19) shows a common stage in the transfer of a motif. The technique is called squaring, and it consists of tracing, on both the finished drawing and the surface to which the figure will be transferred, a grid of horizontal and vertical lines that allows the artist to determine the exact place at which each part of the drawing is to be reproduced. The grid technique was especially useful when enlarging a study to monumental scale, as in the present case: a work intended for a staircase wall of the Musée de Picardie in Amiens.

Sculptors such as Bourdelle, Maillol and Auguste Rodin were tireless draftsmen, trying out bodies in every pose that might suit their compositions. Whether fluid washes that nonetheless give an unmistakable sense of mass, sharp strokes of the pen, or slashes of vivid red chalk, these techniques were used with great precision and evidence a pleasure at experimenting with line.

In these drawings, the body is examined, scrutinized with the same intensity as a landscape; it has lost the sacred terror it once evoked and has come to symbolize either natural beauty or obscenity. It has to be captured in all its postures, from the most banal to the most extreme. Eroticism here is no longer sensual but tragic. Presented as a knowing transgression, it encourages the viewer to reflect upon society.

The modern nude catches women in every state of undress that daily life occasions. It shows them languorously stretching as they wake, stepping into a tub or washing in a basin, lazily reclining on the cushions of deep couches; it interprets their morning postures as they slip on their stockings, their dreamy indolence while at rest, their supple poses before the mirror. These drawings were often preparatory studies for paintings or recollections of a fetching pose caught by the artist's eye. Very rarely were they exhibited through dealers, even though the number of dealers had grown considerably in the last third of the nineteenth century. Instead, art fanciers tended to see such drawings in the studio, where they delighted in their subtle intermingling of dream and reality. The works were often bought privately and shown in the collector's salon for the delectation of a chosen few. "No doubt Woman is sometimes a light," wrote Baudelaire in "The Painter of Modern Life," "a glance, an invitation to happiness, sometimes

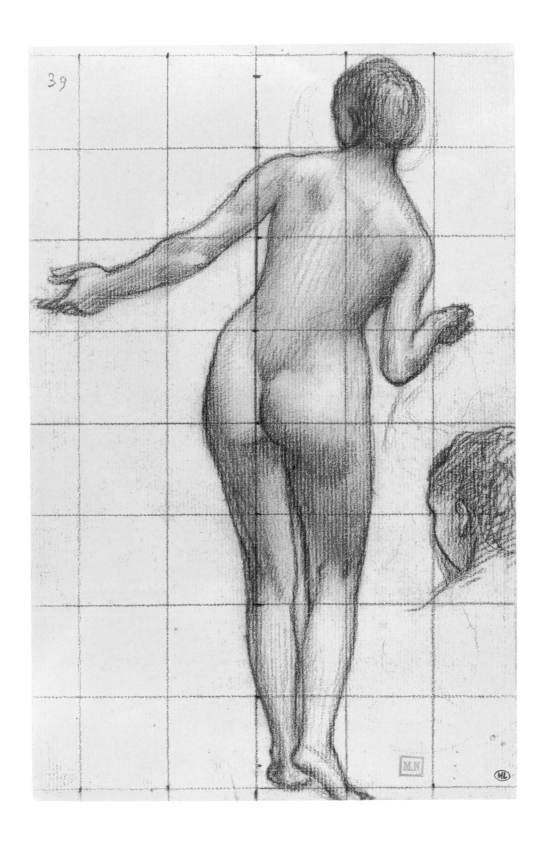

PUVIS DE CHAVANNES, Pierre *Nude Seen from Behind, Left Arm Extended, and Sketch of Her Head /*

Femme nue, vue de dos, le bras gauche tendu, et reprise de la tête 1878–80

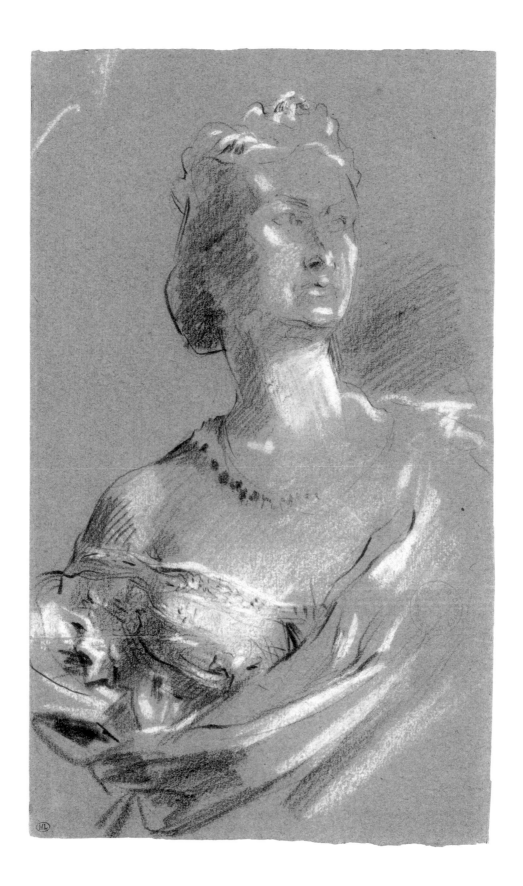

20 **CARPEAUX**, Jean-Baptiste *Portrait of Princess Mathilde / Portrait de la Princesse Mathilde* 1862

just a word; but above all she is a general harmony." Still, a progressive de-idealization of the body during this period would gradually mutate into disfigurement. Renoir's and Bonnard's nudes remain beautiful, but Toulouse-Lautrec's and Rouault's already show a cruel realism. And while the Fauves ("wild beasts") rip their models to shreds, Picasso and Braque dice them into cubes.

WHAT'S IN A FACE

The profound and rapid transformation of French society and its subsequent evolutions were expressed in an unprecedented flourishing of images of women. Never had faces inspired such fascination; never had they aroused such interest in their dissimilarities, such attention to their ability to express the person and her inner self. Faces conveyed a whole gamut of emotional and pensive states, reflecting, perhaps, the increased complexity of social gestures, the refinement and subtlety that went into manipulating "polite society's" codes.

Foremost in depicting these states were portraits, the preferred genre of that new ruling class, the bourgeoisie. Portraits were the mirror of the bourgeoisie's recently acquired social standing; they bespoke a rather smug affirmation of one's self and one's class, of one's membership in a particular world. Portraiture in and of itself offers a key to understanding the nineteenth century. The number of portraits and their dimensions sometimes swelled to extravagant proportions. Indeed, what most characterizes that century is the diversity of portrayals, and their increase. This becomes especially true when one factors in the emergence of photography and the multiplication of prints, as well as the relaxing of boundaries separating such previously distinct genres as portraiture, landscape and historical scenes.

An indispensable mainstay of artists' livelihoods, portraits proliferated in a chaotic and fascinating way. Princesses, bankers' wives, artists' spouses, upper- and middle-class women, even peasants — all of them submitted, for reasons of pleasure, decorum or conformity, to lengthy posing sessions. The more spontaneous the drawing, the better it translated the model's spirit, her rapport with the artist sketching her.

Maintaining tradition, Jean-Baptiste Carpeaux executed a preparatory study for a triumphal bust of Princess Mathilde (p. 20), Napoleon III's cousin, in the style of earlier portraits of prominent individuals. By contrast, his drawing of Empress Eugénie wearing a little bonnet (p. 42) is touching for its dreamy simplicity: this was a sensitive woman, left devastated by the disastrous collapse of the Second Empire, whom he sketched in a meditative pose.

The most common format was the commissioned half-length portrait. It conferred on the work an intimacy and directness, something natural and spontaneous between the painter and

his model, and between the model and her viewer, that made it a highly popular approach. Two drawings in particular — the *Portrait of Hélène Hertel* by Degas (p. 44) and the one of the Countess d'Etchégoyen by Amaury-Duval (p. 41) — typify such commissioned portraits, which were sometimes preparatory sketches for a painting and sometimes meant to stand alone. Both works display a free, rapid, yet monumental technique. The faces are beautiful, with high, smooth foreheads, delicate brows and dark eyes, straight noses that are neither too aquiline nor too broad, pale and fresh complexions, symmetrical and well-proportioned features, and a somewhat languid charm in their gazes that cannot fail to catch and hold the viewer's eye.

Over the course of the nineteenth century, the notion of family veered toward a more closed and restricted concept, often including only blood relatives. Where before artists were seen as belonging to lineages of craftsmen, painters, architects or sculptors, now they were considered individuals who came from varied and often modest backgrounds. Typically, they had trouble obtaining commissions early in their careers, before they had proven their talent. Filial piety, a cornerstone of the bourgeois world, incited young men to draw their mothers' portraits, the same mothers who often nurtured and protected them and played a crucial moral and material role in the development of their vocations. Often these portraits were a kind of artistic manifesto, the expression of an Œdipal obsession very popular at the time. We always sense the same restraint, the same direct and unadorned reality in artists' depictions of their mothers, who come across as dignified middle- or working-class women in their Sunday best, faces serious and indulgent, absorbed in their thoughts or prayers.

In this regard, Charles Angrand's image of his mother (p. 23) is exemplary. In a letter to his friend Paul Signac at the end of 1898, he described undertaking this mysterious, contemplative work: "I'm making a portrait of my mother without, as you can imagine, the childish concern for exact resemblance. It will be the most heavily black drawing I've ever done. The head will be practically the only thing to remain lit. Normally I leave about two-thirds of the sheet in white or halftone. But the drawing is still not finished, as I haven't yet found the final and definitive harmony, the thing that will convince me to sign it: in other words, there's still room to start over." Choosing his paper with utmost care and labouring to perfect the quality of his execution, Angrand worked slowly, taking several months to finish.

In its use of heavy charcoal, Angrand's dramatic work is similar to the "black drawings" of Odilon Redon (p. 48) and, especially, Georges Seurat, who had also drawn enigmatic portraits of his mother bent over her sewing or a book. Other works, such as the nude studies by Maurice Denis (p. 74) and Émile-René Ménard (p. 75), evoke an atmosphere of serenity rather than drama. Both of these latter drawings were done in pastel, sticks of compressed powder that let

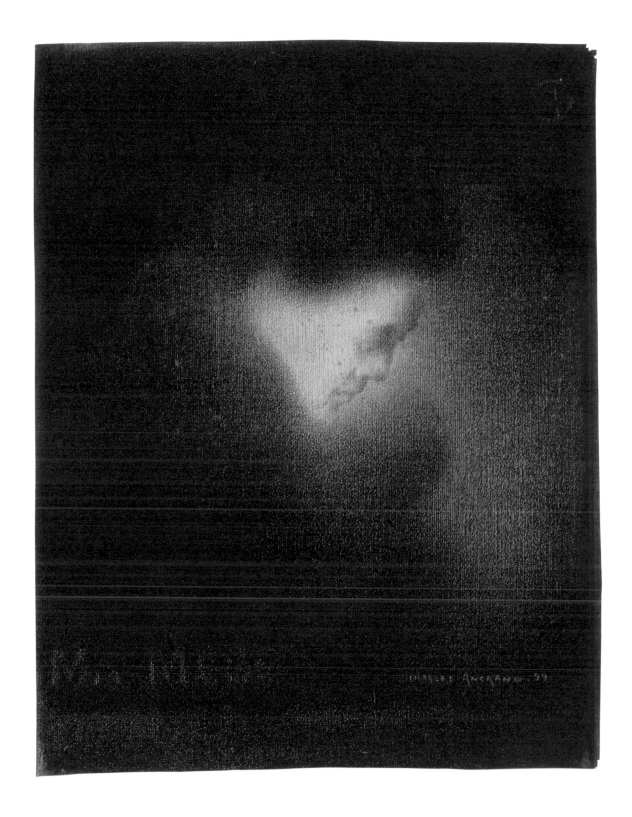

ANGRAND, Charles *My Mother / Ma Mère* 1899

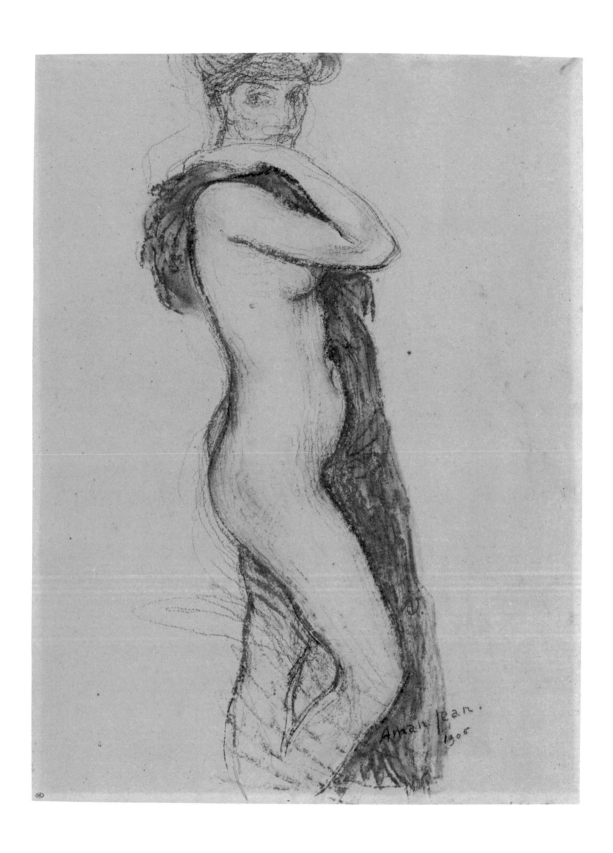

AMAN-JEAN, Edmond-François *Standing Nude in Right Profile, Face Front /*

Femme nue, debout, de profil à droite, la tête de face 1906

colours blend easily on the sheet, making for a velvety softness that emphasizes the complicity between the master and his model. Pastel and other new mediums, such as synthetic charcoal, allowed artists to develop highly sophisticated techniques and gave drawings unparalleled suppleness. Layering their compositions, they were able to analyze the interplay of light and shadow with a remarkably high degree of subtlety.

Little sisters and young brides also served as obliging models, allowing the artist to express partnership, love, tenderness or social position, as well as his notion of the woman's place in his life. Juliette, Gustave Courbet's much younger sister, tired from holding her pose, drifted off to sleep, and from this the artist created a reserved and affectionate image of the little girl (p. 81). Armand Guillaumin, with a few pastel notes, heightened the rendering of his daughter's charmingly attentive and expressive features, the laughter in her astonished eyes lighting up her childish face (p. 52).

In the eighteenth century, Paris was the capital of elegance and taste; in the nineteenth, it became the city in which fashions emerged and evolved. One went there to have one's portrait painted the way one went to Worth's to buy the latest gowns. Full-length, half-length, busts, or just the face, most often alone or with one's children, women posed compliantly before the artist, both for the fun of it and to display their husbands' social ascent.

These portraits, whether pensive, harsh, coy or elegant, bear witness to a tasteful Parisianism or a naïve provincialism, and come in many sizes and compositions. Frivolous or solemn, ceremonial or intimate, they show us the deep and varied lives of their models even as they incarnate their time — the so-called "beautiful epoch" that preceded the apocalypse of the Great War.

In this regard, a significant anomaly — in its technique, its late date (1931) and its subject (a prominent figure in her own right) — is Vuillard's portrayal of the Countess Anna de Noailles (p. 79). A poet and major patron of the arts, the countess is depicted in her bed, surrounded by a certain disorder that typified her way of living and working. This was intended as the first stage of a canvas that would then be covered with paint, but friends convinced Vuillard to leave it as is, thereby preserving its spontaneity, energy and synthetic power. The subject and the light seem perfectly matched. The woman's expression, conveying a lyricism at once voluble and solemn, rings true.

These many examples represent a watershed moment in which the art of portraiture itself, with its serene, monumental, hieratic likenesses, was called into question; in which visible content progressively receded to make way for the resolution of technical issues. Permanence, change, transmutation — all of it blended in an especially rich and rapid way, offering a constantly evolving image. The age of psychological portraits was past, and in the twentieth century the depiction of women would cease being a topic of æsthetic debate. All that remained were problems of pure painting.

PARIS, QUEEN OF THE WORLD

The tumult in the street had deafened me…
— Baudelaire, "To a Woman Passing By"

You swarming city, city filled with dreams,
Where ghosts in daylight clutch at passers-by!
— Baudelaire, "The Seven Old Men"

Where all things, even horror, cast delight…
— Baudelaire, "Little Old Women"

"We must be absolutely modern." Arthur Rimbaud's exhortation from 1870 was the starting point for every modernist quest, from the age of the avant-gardes to the present, and even now it continues to hold sway. But how? At the end of the nineteenth century, the choices were many: free verse before automatic writing; musical chromaticism (Wagner, Debussy) foreshadowing the end of tonality (Schoenberg); sketches from life, hazy outlines and colour for its own sake leading to abstraction. Drawings from this period strike us as familiar because the æsthetic that governs them triumphed and now appears self-evident. But we should beware the retrospective self-evidence of triumphant æsthetics: we understand these drawings *a bit too well*, perhaps better than we do a sublime sketch by a Renaissance master. They display no goddesses, but rather paint and sketch everyday women. They *depict Reality*, the deity of modern times — a shattered, decomposed reality, pursued and hunted until it blows apart (see Picasso, Joyce, Schoenberg). We must be absolutely modern in form and substance, so as not to be relegated, like those luckless academic hacks, to the trash bins of history.

To be modern is to be an *urbanite*. "I am an ephemeral and not-too-discontented citizen of a metropolis thought to be modern," says Rimbaud (*Illuminations*). And for a French artist, being urban means being in Paris. It means being a *pedestrian* of the capital, like those tireless strollers, curious about everything, who populate the works of Balzac and Baudelaire (and who later reappear in Walter Benjamin's writings on Paris, such as *The Arcades Project*). *La Comédie humaine* is on view at every street corner. What a feast for the novelist and the sketch artist! So many scenes to render, faces to capture, as in those wonderfully harsh and exuberant drawings by Daumier! On February 8, 1852, Gustave Flaubert wrote to his confidante Louise Colet: "Now I am in an entirely different world, a world of attentive observations of the most humdrum details." Both the draftsman and the writer have turned into insatiable observers, witnesses to the mores of their time. Impenitent walkers, they capture the transformations of their society.

Never have people *walked* so much — and this goes for the "modern woman" as well. Alone, or with her chaperone or a girlfriend, she haunts the newly established Paris cafés, embodying our curious gaze at the world around us and, even more so, embodying our solitude. The crowd is never gay; the woman, like the rest of us, sinks into the sea of humanity and its undifferentiated swells. But modernity is there, in that multi-layered city where Joyce's Ulysses loses his way, in order, perhaps, to find it. Woman, the city: two sides of the same modernity. As these drawings tell us (and never, *never*, had it been shown this way in previous centuries), this is also every-day life — in other words, the immediate form of the real. Women are its subject, witness, victim and heroine. Boudoir to sidewalk, intimacy to public space: woman is our Beatrice and we her terrified Dante, in the endless perspective of daily life and aging capitals. None of this should surprise us: it's where the modern world begins.

THE CABARET AS HEAVEN AND HELL

Certain Paris cafés in the last third of the nineteenth century became meeting places, centres for the exchange and confrontation of artistic ideas — such as the Nouvelle Athènes at 9 place Pigalle (p. 102), which in 1871 served as the cradle of Impressionism. Manet stopped in almost daily. Bazille, Sisley, Renoir, Degas, Seurat, Gauguin, Pissarro, Toulouse-Lautrec, Forain — nearly all of them had studios in the up-and-coming neighbourhood. Forward-thinking columnists and Académie-hating writers such as Emile Zola, Guy de Maupassant and Joris-Karl Huysmans were also regulars, endlessly debating ideas, ideals, fantasies and speculations that sometimes brought them to blows.

That same period saw the rapid rise of popular theatres, mainly located along the wide boulevards just north of the city's centre — an area already familiar to the capital's literary and financial populations, who now found themselves rubbing shoulders with "gay Paris." This world of boulevard theatres and their dubious entertainments was nicely captured by Zola, in his novel *Nana* (1880), as a chaotic manifestation of the Devil. Zola describes the ambiguities, depravations and especially the cruelty of this modern Babylon, where in the dim auditorium light the courtesan and the actress become ceremonial creatures, objects of public pleasure. But they were more than this: they were also artists plying their trade, independent women who earned their own living as actresses and dancers, and not (or not necessarily) as sex workers. Some, such as Sarah Bernhardt (p. 88) and Isadora Duncan (p. 28), went on to become veritable idols in their time, and legends long afterward.

If one were to propose a kind of ideal and synthetic image of the period, it would be of a woman seated before her glass in a café, while onstage, in the harsh artificial light from the gas

BOURDELLE, Émile-Antoine *Isadora Duncan Dancing / Isadora Duncan dansant* c. 1910

lamps — a sign of the new luxury — an indistinct chorus girl lifts her leg. The *café-concert* or cabaret, the lowbrow theatre of the boulevards, the brothels and dance halls, and those who frequented them (courtesans, "it" girls, factory girls, streetwalkers, kept women), all stand out against a backdrop of absinthe, barroom ditties and violent, joyless sensuality. Maupassant brilliantly endowed this variegated world with literary potency and, strikingly enough, visual artists — whether Realists, Impressionists or otherwise — depicted the exact same thing. The cabaret was the common man's fin de siècle Olympus, the concert stage his hell and his heaven, the bordello his obscure truth and the scaffolding for the countless fears and fantasies it aroused. Toulouse-Lautrec was master of this universe, in which art nouveau blossomed into decadence: his *Blonde Madam* (p. 106). more intimidating than Manet's *Olympia* and "hideously comic," like a Goya revisited by Fellini for Baudelaire's amusement, provides a perfect image of the *Belle Époque*. From one century to the next — until World War I sucked all that staggering, naïvely toxic decay into its mælstrom — the petit bourgeois version of Roman decadence spread throughout Paris and the provinces, from the Moulin de la Galette to the House of Tellier, from La Grenouillière to the *grands boulevards*.

WOMEN AMONG THEMSELVES

In nearly all of these drawings (an exception being Renoir's charming and optimistic *The Country Dance* (p. 123)), men simply have no place. Surely at no time other than the turn of the twentieth century was the separation of the sexes so tightly linked to the tragedy of love. "Woman will have Gomorrah and Man will have Sodom": these famous lines by Alfred de Vigny, which Proust cited in epigraph, could be the sexual formula of the age — and indeed, lesbianism was a major theme for many of the period's artists and writers, from Courbet, Baudelaire and Maupassant to Proust and Colette. Homosexuality in general, at least as portrayed in art, often bespeaks a certain sexual uncertainty, a sign of transitional (not to say decadent) periods. In the world of 1900, it was primarily female homosexuality that was put on display, perhaps as an effect of nascent feminism, among other things.

Here, leaving aside the portraits and nudes, which are *genres*, what strikes us most is the solitude of all those women, usually sitting alone in cafés, smoking cigarettes. They treat themselves to an absinthe on afternoons when they'd like to escape their woes, as if melancholy, what Baudelaire called *spleen*, were draping its black flag over them. No, Renoir notwithstanding, women weren't having much fun at the turn of the century. Bourgeoise or coquette, she experienced *urban solitude* for the first time: alone in the city, alone in the streets, alone in the cafés, as alone

as the city itself in its infinite solitude. Paul Helleu's *Woman Leaning on a Table* (p. 103) bespeaks a terrible wistfulness. Vuillard offers his own *Woman Sitting in a Bar* (p. 6), its flat tints similar to the ones used in the colour engravings that he (along with Toulouse-Lautrec and Bonnard) was then producing for *La Revue Blanche*. The modernity of the subject comes from the specificity of the scene, its location in a harshly lit public space. Vuillard's simplified forms and flat surfaces set off the figure of the woman, but without making her a caricature. Her face is a nuanced daub, applied with a firm brush. The tones in the crown and brim of her hat, the colours of her dress, and the volume of the boa she wears as she leans on the pedestal table all heighten this sense of modernity. Like Helleu's woman, she is alone in a Montmartre café. Similarly, Toulouse-Lautrec shows two women drinking in a café (p. 31). This drawing, rapidly sketched, illustrated an article by Gustave Geoffroy, "Paris Pleasures: The Balls and the Carnival," published in *Le Figaro illustré* in February 1894. The critic Claude Roger-Marx was an admirer: "It has been a long time since I've seen an artist as talented as M. Toulouse-Lautrec, whose authority perhaps derives from the concordance between his faculties — by which I mean between his penetrating analysis and his acute means of expression. His cruel, implacable sense of observation is reminiscent of Huysmans or Becque, or anyone who seeks to reveal the subject's intimate temperament beneath the mask of outer appearance" (*Le Rapide*, February 13, 1893, apropos an exhibition at Boussod et Valadon).

All things considered, it is encouraging that one of the most sensually contented scenes, in the peaceful and narcissistic intimacy of the mirror, should be by a woman artist, Berthe Morisot (p. 32): left on her own, the woman is finally free to *reproduce herself.*

LUSTROUS LOCKS, SORROWFUL DANCERS

Depicting women with their hair loose, brushing it or having it brushed in the *cabinet de toilette* (a new, intimate setting that Haussmann's buildings had introduced), was one expression of the gaze now posed on female intimacy. The woman's bath was closed to the male world, and so gave rise to numerous fantasies. The subject of a woman at her toilette, with few direct antecedents in Antiquity or the Bible, is among the most evocative aspects of the latent eroticism that imbues the end of the nineteenth century.

The toilette, performed exclusively among women, often before a mirror that reflects one's own image, expresses an instinct for modern life. The more the woman's hair is combed, brushed, fluffed out, the more lustrous it becomes, and its opulence fascinates aristocrats and bourgeois gentlemen alike. Jeanniot, Renoir and many others explored, observed and symbolized the

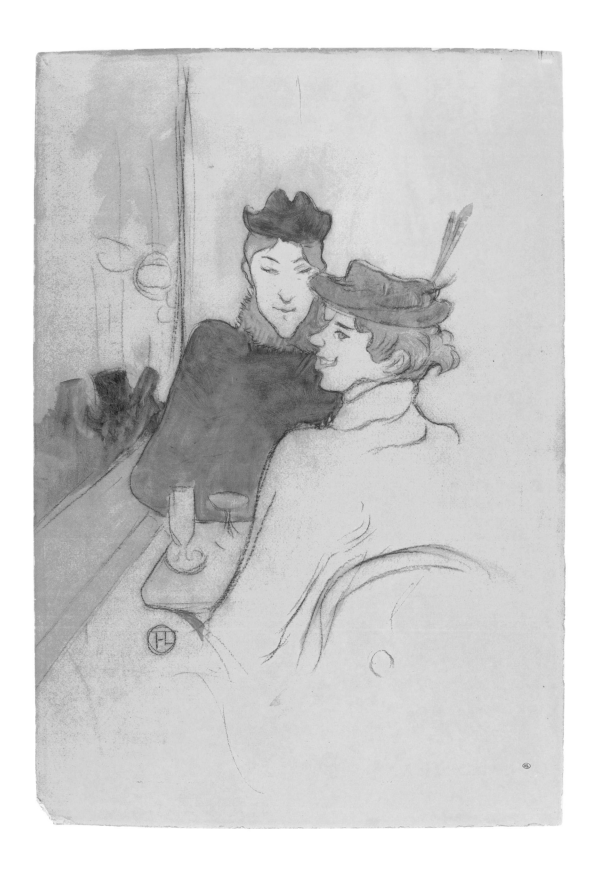

TOULOUSE-LAUTREC, Henri de *Two Women Sitting in a Café / Deux femmes assises au café* 1893

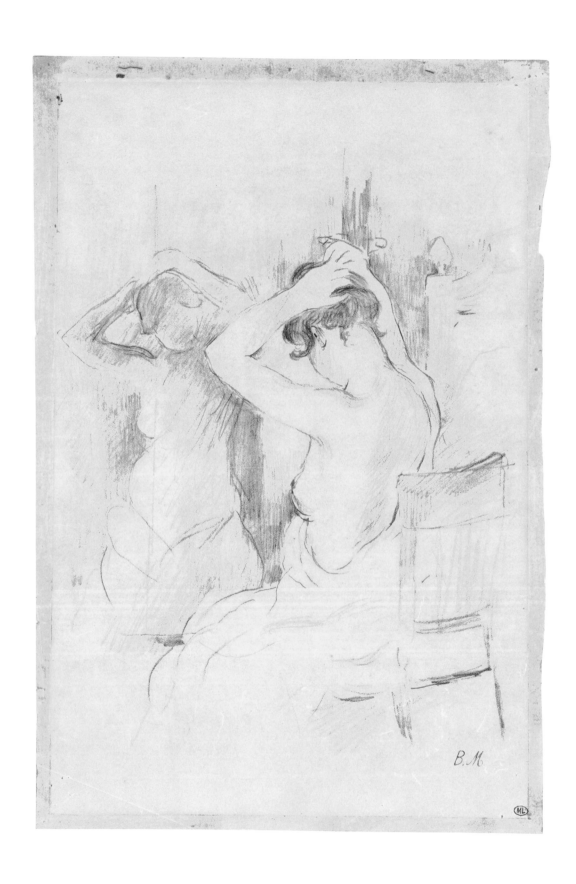

MORISOT, Berthe *Half-Nude Woman Fixing Her Hair, Seen from Behind, Her Body Reflected in a Mirror /*
Femme demi-nue, vue de dos, se coiffant, une glace reflétant son corps 1891

erotic fantasy of a woman's hair falling free and loose as a sign of intimacy—just as, in Zola, Nana's golden locks spilling over her naked shoulders disturb and captivate Count Muffat.

Legend has it that in 1878, Degas shocked the family of his close friend Halévy, the composer, by asking if he might witness a quintessentially intimate scene: Geneviève Halévy brushing her especially long, thick hair. The theme of women's hair would recur constantly in the artist's work, becoming almost an obsession: its scent, its suppleness, its lightness or heaviness, its opulence set Degas dreaming and allowed him to explore the female body in all its poses.

In a similarly erotic vein, Degas' ballerinas (p. 95) are not merely the "soul of dance" and movement, but also the young ladies of the Opera, the kind any man who enjoyed aristocratic or bourgeois privilege was expected to take as his mistress. (The myth of the kept actress/dancer/ courtesan was among the most potent of the late nineteenth century.) It is clear why these ballerinas at rest always trigger a vague sense of melancholy in Degas. What passes through all these images, what all these women—singers, dancers, streetwalkers or just barflies—*represent* is the confusion of genres, be they sexual, social or artistic. Cafés, houses of ill repute, the backstage of theatres: all are places of female triumph and degradation, where the obscene reflections of the *Belle Époque*'s decadence are played out.

THE DAZZLE OF FLESH

Then Manette climbed onto the posing table with her shift bunched tightly against her chest, holding the upper trim between her teeth, with the huddled, modest gesture of an honest woman changing her undergarments.

For, despite their trade and habits, these women have their pride. The creature who is about to make herself public, deliver herself fully to men's eyes, instinctively blushes, so long as her heel does not alight on the wooden pedestal: for the moment she rises upon it, the woman becomes a cold, immobile natural statue, whose sex is mere form. Until that moment, when the falling shift calls up from her absolute nudity the rigid purity of marble, the model retains a shred of modesty. The state of undress, the glide of her garments over her body, the idea of portions of her skin being revealed one by one, the curiosity in the eyes of those expectant men, the studio on which the discipline of study has not yet descended— all of this gives the model a vague and involuntary feminine shyness, which makes her conceal herself with her movements and wrap herself in her poses.

It is as if she were donning her modesty along with her shift ... Only in posing is a woman no longer a woman, and men for her no longer men ... She sees herself watched by

artists' eyes. She sees herself standing nude before the pencil, the palette, the studio; nude for art, in that almost sacred nudity that quiets the senses.

— Edmond and Jules de Goncourt, *Manette Salomon*, 1867

Nana was naked. She stood naked with calm audacity, sure of the omnipotence of her flesh. Mere gauze enveloped her. Her round shoulders, her proud breasts, their rose-colored nipples standing erect and firm as lances, her wide hips that rolled with a voluptuous sway, her fleshy blond thighs — her entire body showed freely beneath the foamy white of the diaphanous fabric. She was Venus rising from the waves … with the sharp smile of a man-eater. …

One of Nana's pleasures was to undress in front of her mirrored armoire, where she could see herself full-length. She let all her clothes slip from her, including her shift; then, completely naked, she let her mind drift, contemplating herself at length. It was a passion for her body, a delight in the satin of her skin and in the supple line of her waist, that kept her serious and attentive, absorbed in her self-love.

— Emile Zola, *Nana*, 1880

THE ROOFTOPS OF PARIS

The critic and the art dealer have this in common: they both believe in the power of the *signature*. Nonetheless, even the most illustrious artists can display more than their share of mediocrity, just as — though less frequently — an untrained artist, or at least one now deemed secondary, can enjoy a stroke of genius. One of the most remarkable drawings included here is by Jean-Louis Forain (p. 35), a friend of Degas' whom posterity now remembers chiefly as an illustrator. The drawing shows a young woman standing on a balcony, contemplating the Paris rooftops. The subject is wonderful, of course, emblematic of the brutal changes the city had recently undergone; the slightly lax technique is vaguely Impressionistic. But what immediately grips the viewer is the work's mythic *charge*: it distantly evokes, several decades after the fact, Caspar David Friedrich's young woman at a window looking out at ships, and especially predates (by so little!) most of Edward Hopper's canvases. Here, the woman wears a dress typical of the Parisian middle class, with high collar and a row of small buttons, closed to the throat, that underscore the decorum expected of a woman of her standing. Still, as the cut of her dress tells us, she is also fashionable. She is standing on the uppermost balcony of a Haussmann apartment building, its railing characteristic of this new type of architecture. What is especially touching about the scene is the woman's pensive expression: she is lost in thought above this great metropolis, the smoke from its chimneys evoking industrialization, transformation and her own dreams.

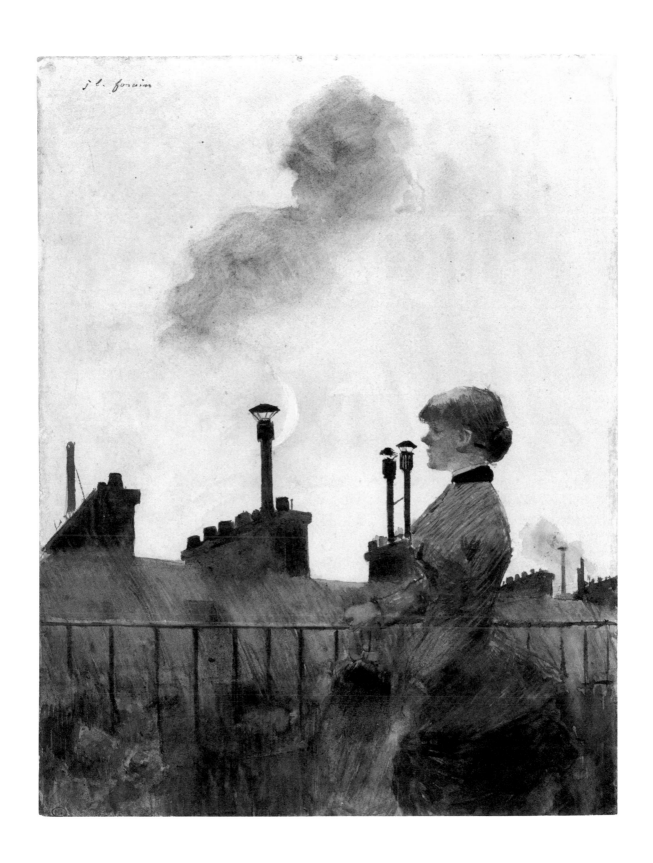

FORAIN, Jean-Louis *Young Woman Standing on a Balcony Contemplating the Paris Rooftops /*

Jeune femme debout sur un balcon, contemplant des toits parisiens C. 1890

The city here emerges in all its grime and glory. Paris! Capital of the late nineteenth and early twentieth centuries (New York would need almost a hundred years to take its place), capital of capitals, like the Roman *Urbs*. Paris, queen of the New World, home of Universal Expositions to which people flocked from the provinces and abroad. Paris, "where all things, even horror, cast delight." Paris, the subject of so many great works, the myth incarnate of the *Belle Époque*. Hence the formidable power of those chimneys punctuating the sky: the rooftops of Paris equal the modern city. The art of the cinema is already present in this. And it's no coincidence that a *woman* is staring at these rooftops. Woman is the true contemplator of the cityscape — her sister, enemy and accomplice. We are again reminded of Hopper's paintings, as well as of Michelangelo Antonioni's films: almost always, it's a woman who stands before the city, who wanders through it, whom one sees alone in her room through the lit window of a building. A woman measures her solitude and her fascination against those of the city itself. That is why this drawing, which truth be told is fairly modest, is also unusually striking: it puts a cap on Romanticism, makes use of Impressionism, but already expresses all the modernity to come. All it needed was a woman, a hazy, crepuscular sky tinted green by natural gas, a few factory smokestacks belching their soot into the pale air, and the Paris rooftops. How can we not think yet again of Baudelaire, who understood the new Paris so well? "Tonight the moon dreams more indolently…" ("Sorrows of the Moon").

LANGUOROUS GIDDINESS

We must be wary of the period from 1850 to 1920. Between those two dates — that is, between the Second Empire and the Dreyfus Affair, colonial expansion and the Great War, Balzac and Joyce, Offenbach and Schoenberg, Courbet and Kandinsky — history (including art history) accelerated at dizzying speed, and each of the drawings shown here reflects that in its own way. All of these drawings depict women or girls, but (and this fact alone can make one's head spin) all of them, though they mainly date from the late nineteenth century, take a different æsthetic stance, be it post-Romanticism, Realism, Symbolism, Impressionism, Pointillism and so on. These æsthetics overlap; the constant shift of avant-gardes and the principle of always making it new, unthinkable in classical art, vary from one decade to the next, one year to the next. Still, what is striking when one looks at these drawings, what profoundly unites them despite everything — and this is no coincidence — is the fierce, sometimes unconscious will toward *realism*, a novel idea in Europe. Daumier, Courbet, Toulouse-Lautrec, Degas, Renoir, Pissarro (for in the end, Impressionism is nothing other than a slightly exaggerated Realism, like the literary stream

of consciousness) — all of these artists are in search of Truth, or at least their notion of it, more than of Beauty. The Western gaze has changed: what it now wants is to capture the pose of the cabaret girl, the weary and elusive body of the dancer — like the shadow of Dibutade's lover.

EPILOGUE

I know of no art that engages the mind *more than drawing. Whether one aims to wrest a discovered* line *from the complexity of vision, to summarize a structure, to keep one's hand in, to* read *and* pronounce *a form* in oneself *before* writing *it; or whether sheer invention predominates and the idea imposes itself, sharpens itself, enriches itself through its emergence on the sheet and before one's eyes, every intellectual faculty is involved in this endeavour, all of the person's character traits are fully implicated — assuming he has any.*

— Paul Valéry, *Degas Danse Dessin*, 1938

Essay translated from the French by Mark Polizzotti

THE PORTRAIT

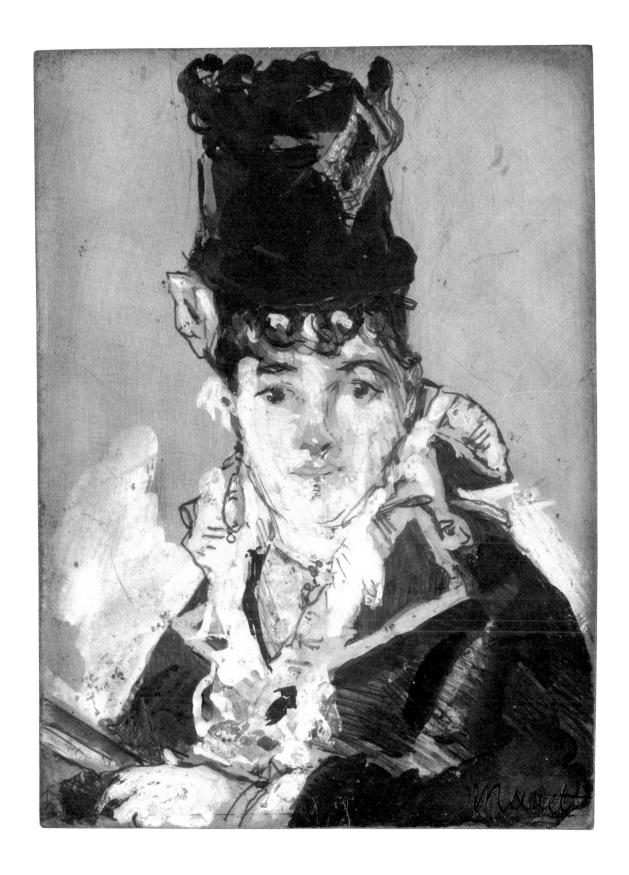

MANET, Édouard *Portrait of Nina de Villard (Madame Callias)* / *Portrait de Nina de Villard, Mme Callias* 1873–74 39

DAUMIER, Honoré *Head of a Young Woman Leaning Forward, in Right Three-Quarter View /*

Tête de jeune femme, penchée de trois quarts à droite 1830

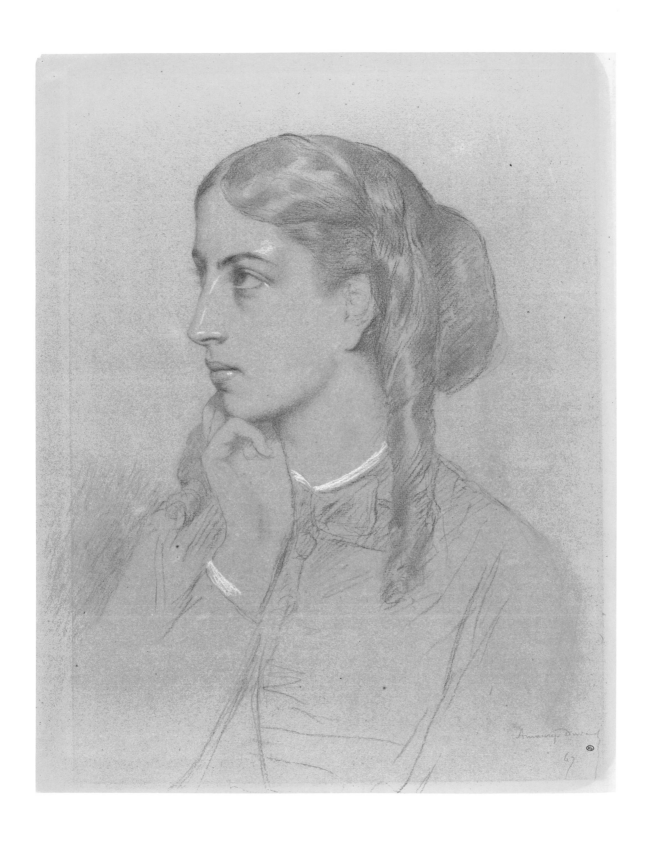

AMAURY-DUVAL, Eugène *Portrait of the Countess d'Etchégoyen as a Young Woman /*

Portrait de la Comtesse d'Etchégoyen, jeune 1867

41

CARPEAUX, Jean-Baptiste *The Empress Eugénie Wearing a Bonnet / L'Impératrice Eugénie en bonnet* c. 1870

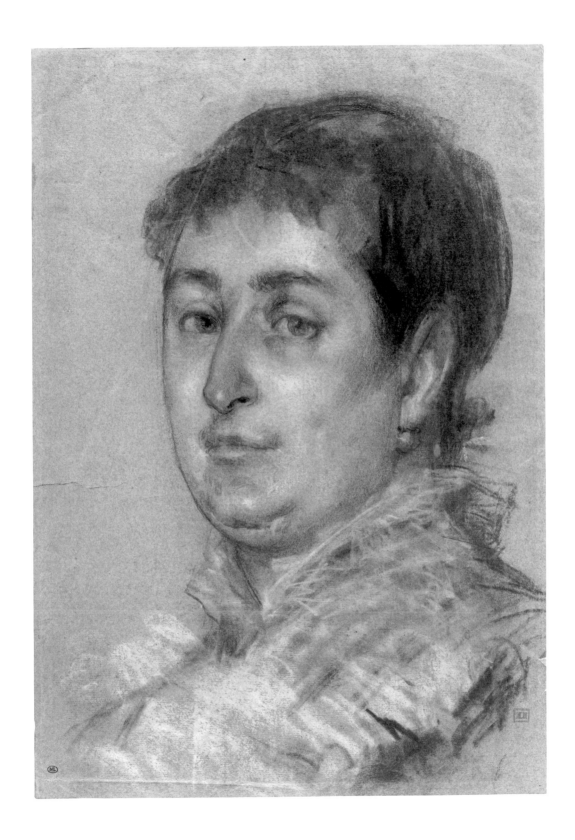

CARRIÈRE, Eugène *Head of a Woman in Left Three-Quarter View / Tête de femme, vue de trois quarts à gauche* 1895–1900 43

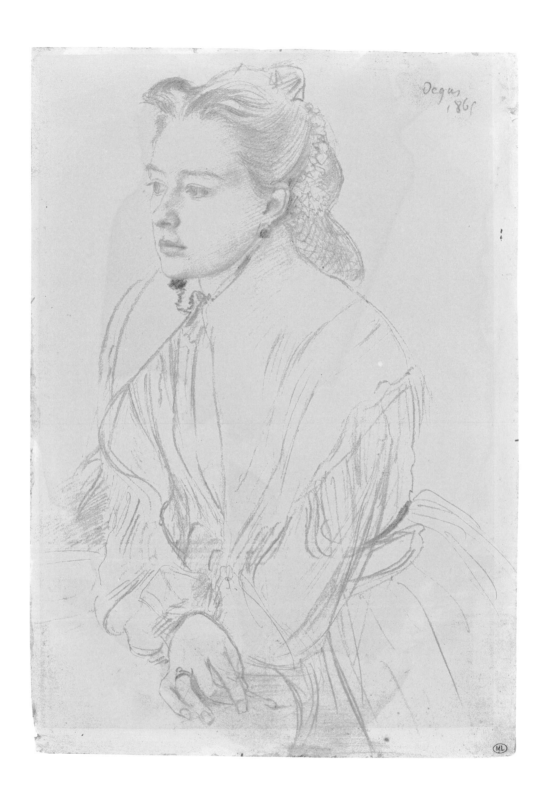

DEGAS, Edgar *Portrait of Hélène Hertel / Portrait de Mademoiselle Hélène Hertel* 1865

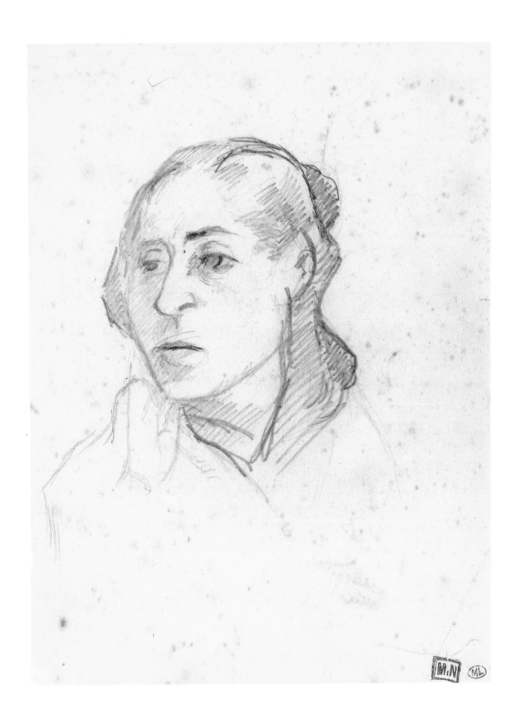

GAUGUIN, Paul *Bust: Study for a Woman's Head / Étude de tête de femme, vue en buste* 1886

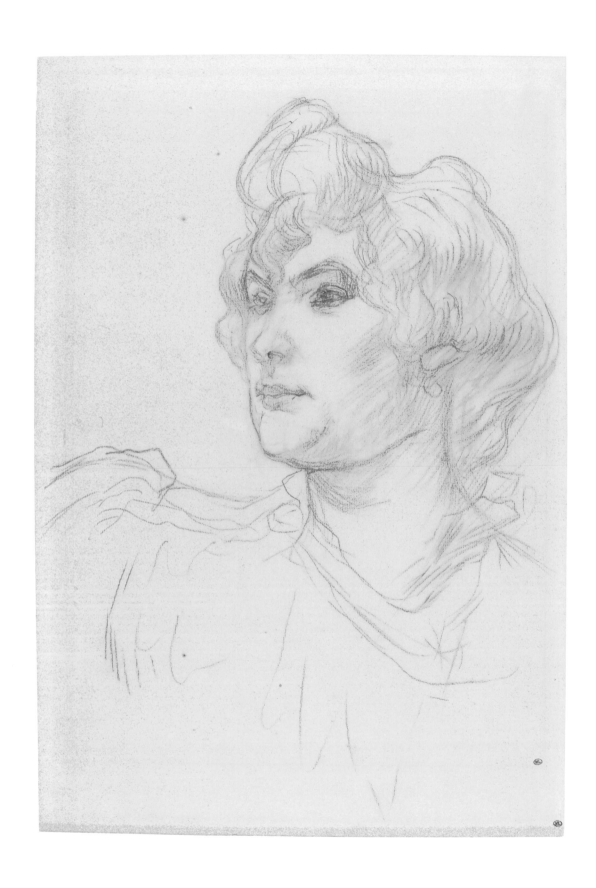

TOULOUSE-LAUTREC, Henri de *Head of a Woman in Left Three-Quarter View /*
Tête de femme, vue de trois quarts à gauche c. 1896

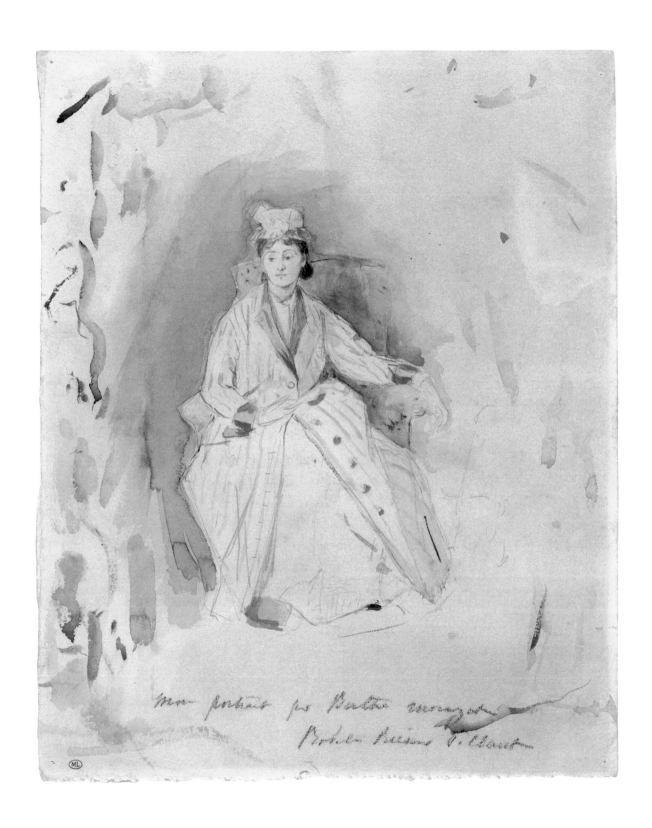

MORISOT, Berthe *Portrait of Madame Pillaut / Portrait de Madame Pillaut* 1866

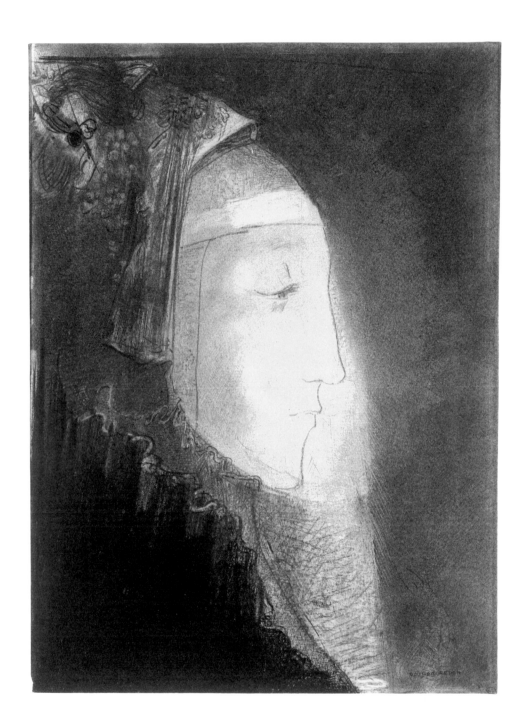

REDON, Odilon *Profile of a Veiled Woman (Profile in Light)* / *Profil de lumière : profil de femme voilée* c. 1885

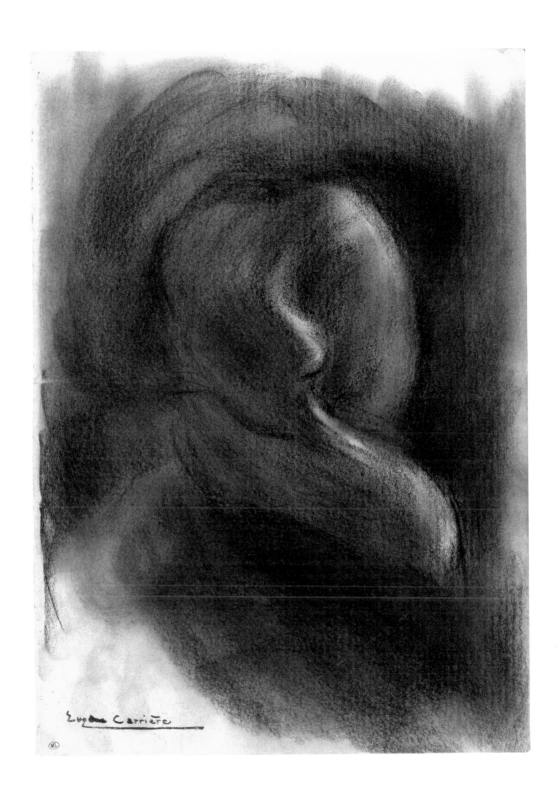

CARRIÈRE, Eugène *Bust of a Woman in Frontal View, One Hand Posed on Her Right Cheek /*

Femme en buste, de face, une main posée sur la joue droite 1895–1900

49

50 **LEGROS**, Alphonse *Half-length Portrait of a Little Girl Holding a Doll | Petite fille, à mi-corps, tenant une poupée* c. 1870

SCHUFFENECKER, Émile *Portrait of Mademoiselle Fontalirand / Portrait de Mademoiselle Fontalirand* 1894

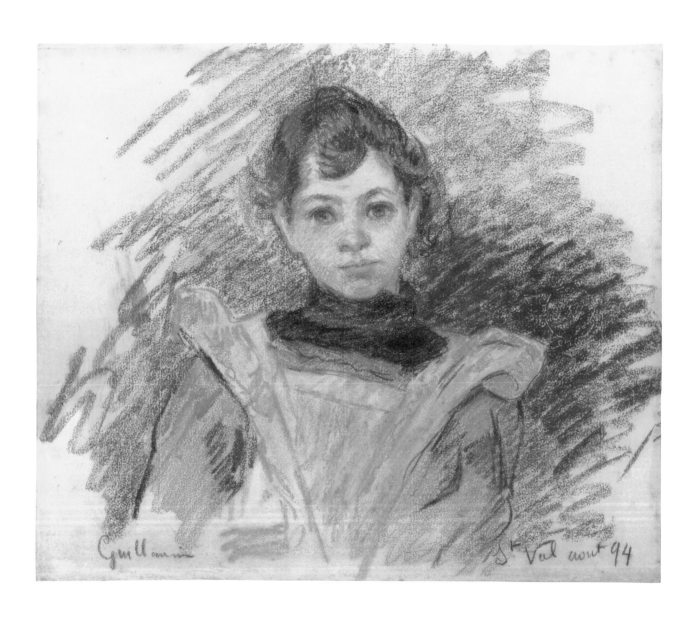

GUILLAUMIN, Armand *Portrait of a Little Girl with Red Hair / Portrait de fillette aux cheveux roux* 1894

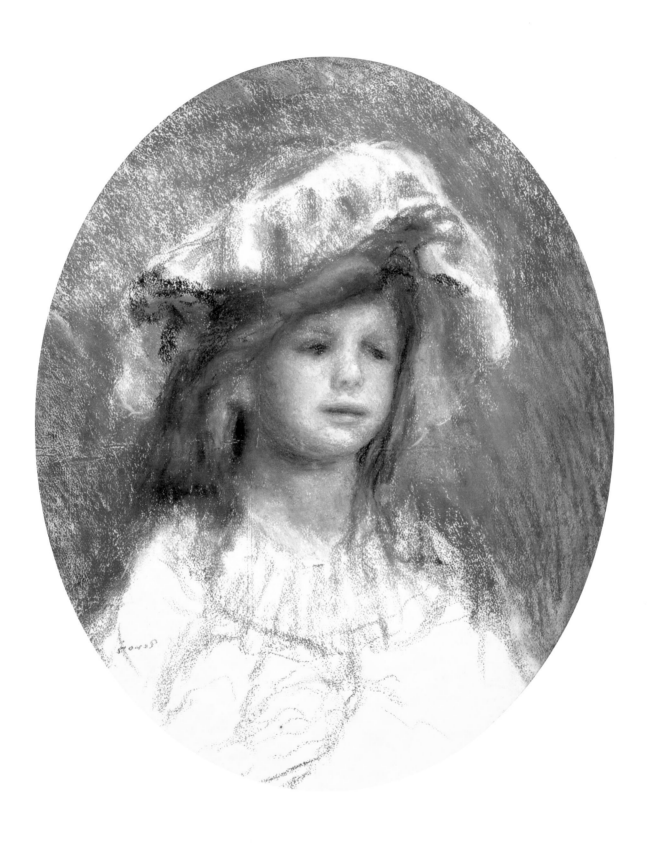

RENOIR, Pierre-Auguste *Bust of a Little Girl Wearing a Large Mob Cap /*
Portrait de fillette en buste portant une vaste charlotte 1900–1906

THE NUDE

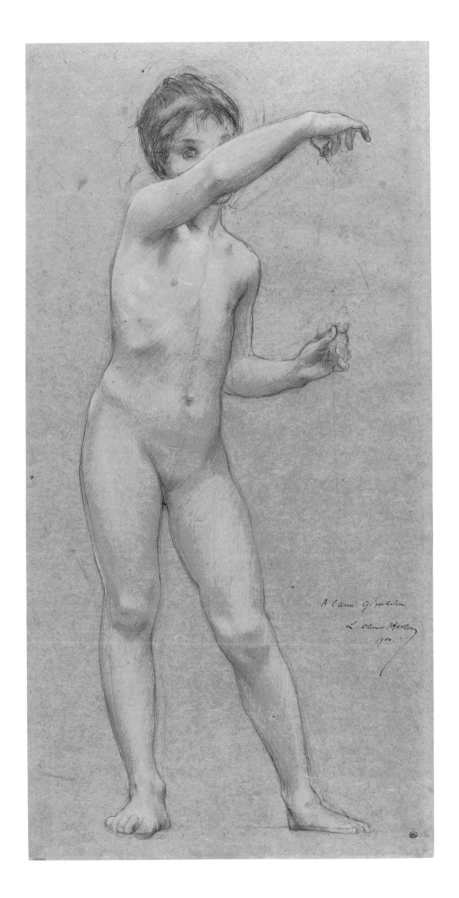

MERSON, Luc-Olivier *Standing Young Nude in Right Three-Quarter View /*
Jeune fille nue, debout, de trois quarts vers la droite c.1900

DAUMIER, Honoré *Two Sketches for a Ballerina / Deux esquisses pour une danseuse* 1849–50

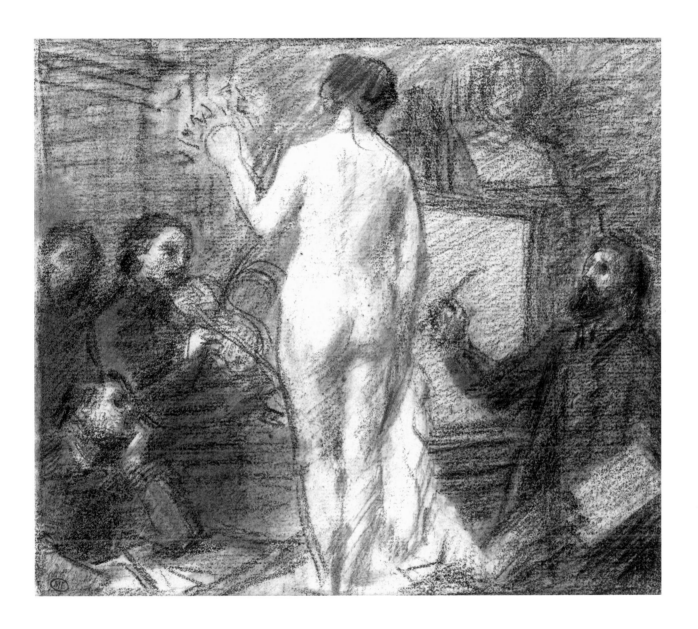

FANTIN-LATOUR, Henri *Truth / Vérité* 1864

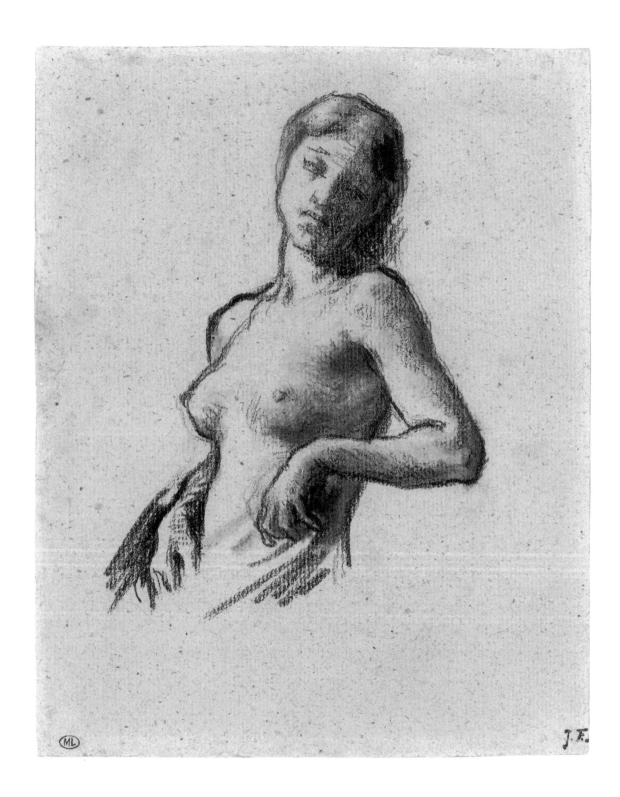

MILLET, Jean-François *Bust of a Young Nude / Buste de jeune fille nue* 1849–50

GAUGUIN, Paul *Bust: Study for a Woman's Head / Étude de tête de femme, vue en buste* 1886

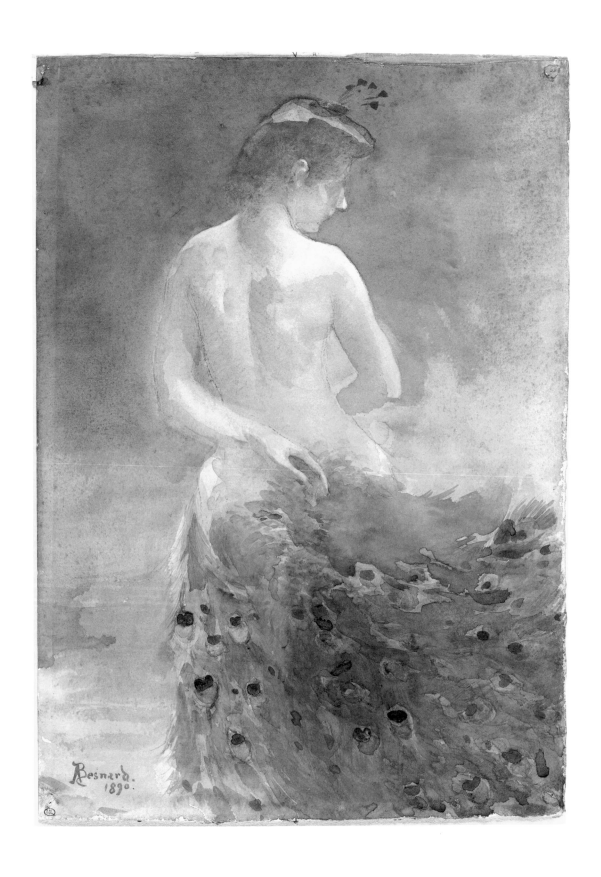

BESNARD, Albert *Nude Seen from Behind with a Peacock Feather, Head in Right Profile /*
Femme nue, de dos, avec une queue de paon, la tête de profil à droite 1890

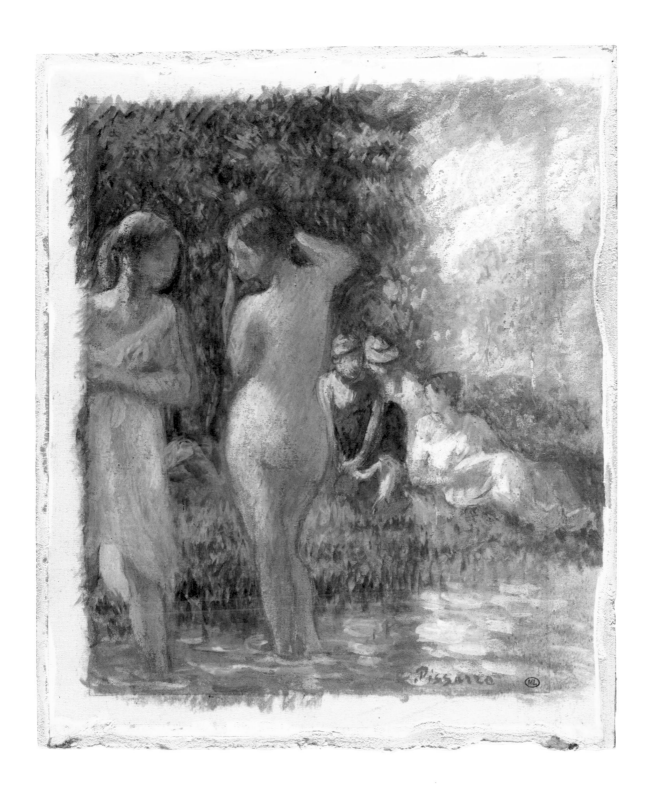

PISSARRO, Camille *Group of Bathers at Water's Edge / Groupe de baigneuses au bord de l'eau* 1894–96 61

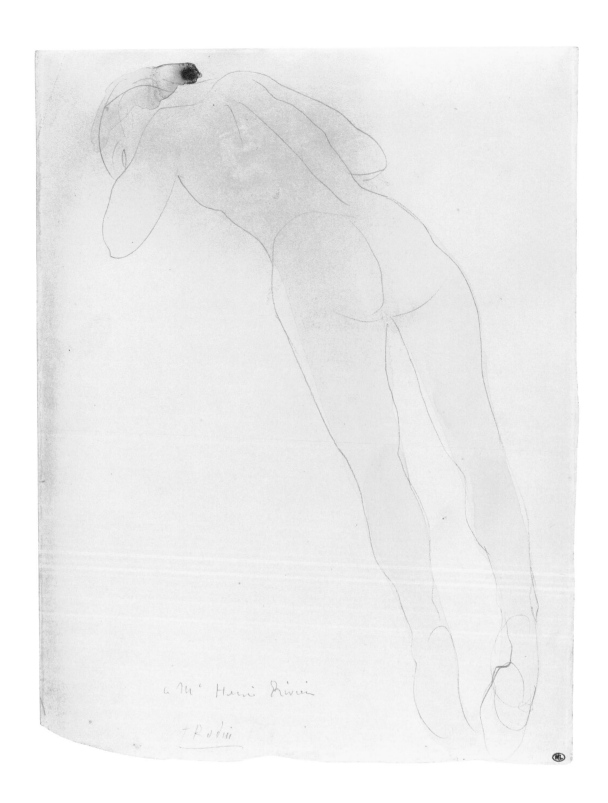

RODIN, Auguste *Woman Lying on Her Stomach, Seen from Behind / Femme nue, de dos, étendue sur le ventre* 1896–1900

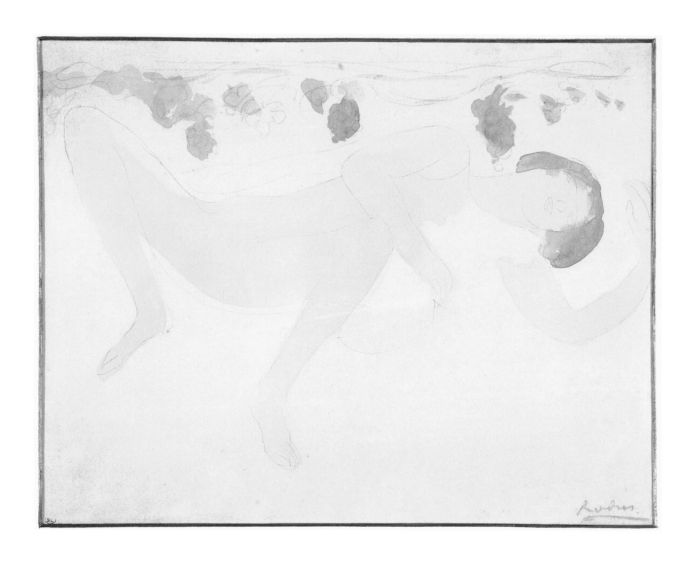

RODIN, Auguste *Female Nude Reclining on Her Back / Nu féminin, étendu sur le dos* 1896–1916 63

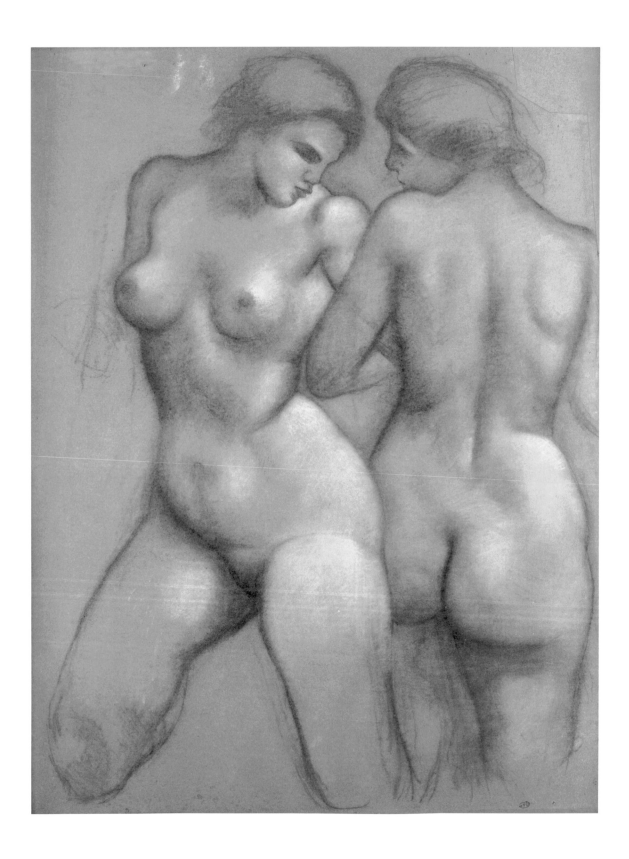

64 **MAILLOL**, Aristide *Two Nudes, One Frontal, the Other from Behind / Deux femmes nues, l'une de face, l'autre de dos* 1937

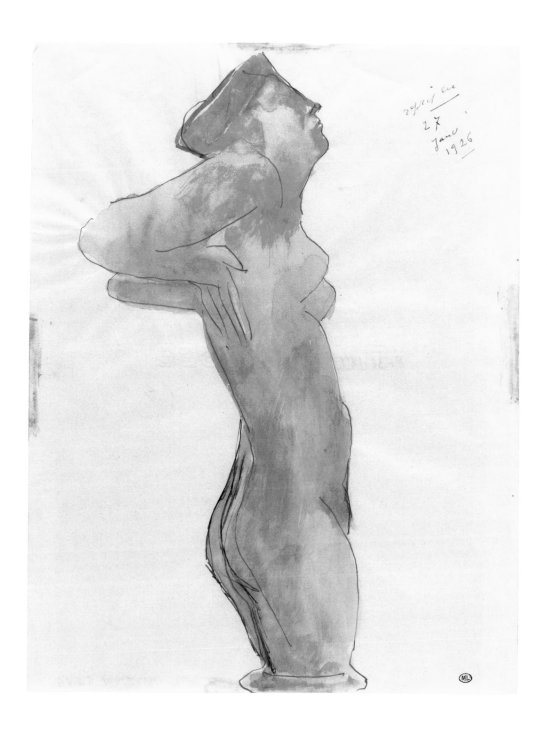

BOURDELLE, Émile-Antoine *Amphora (Female Nude)* / *Amphore : nu féminin* 1927

THE SPACE OF INTIMACY

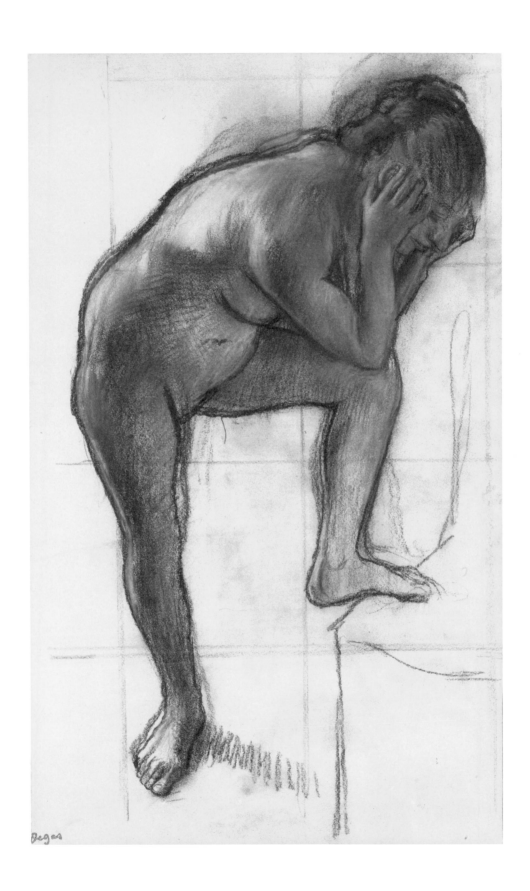

DEGAS, Edgar *Standing Nude with Left Leg Raised, Foot Resting on a Base /*

Femme nue debout, la jambe gauche levée, le pied sur un socle 1882–85

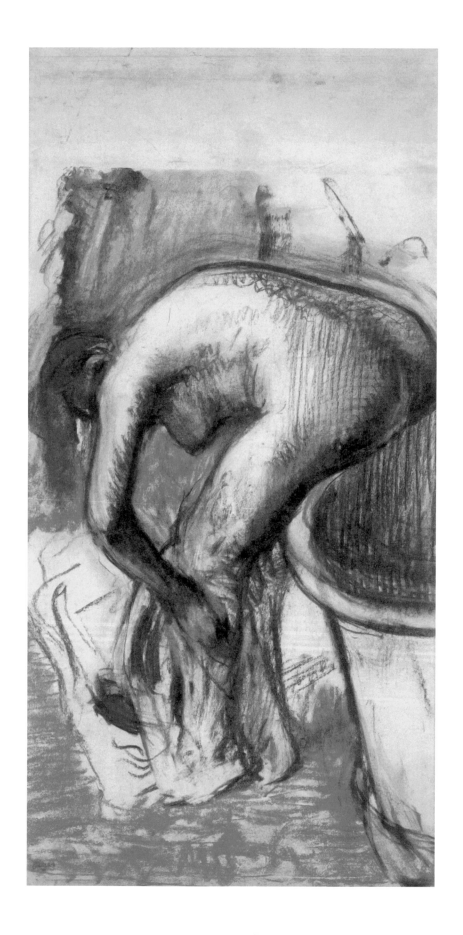

DEGAS, Edgar *Bather Drying Herself / Baigneuse s'essuyant* 1900–05

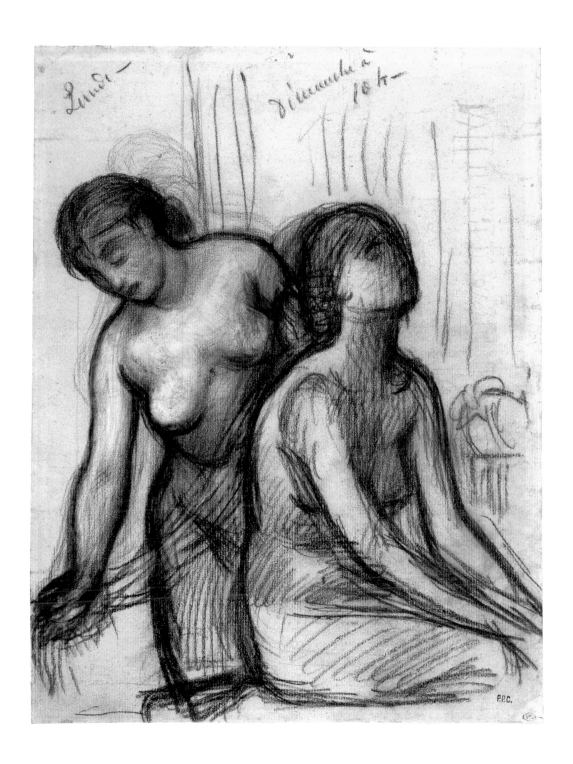

PUVIS DE CHAVANNES, Pierre *Woman Brushing a Seated Woman's Hair / Une femme coiffant une femme assise* 1883 69

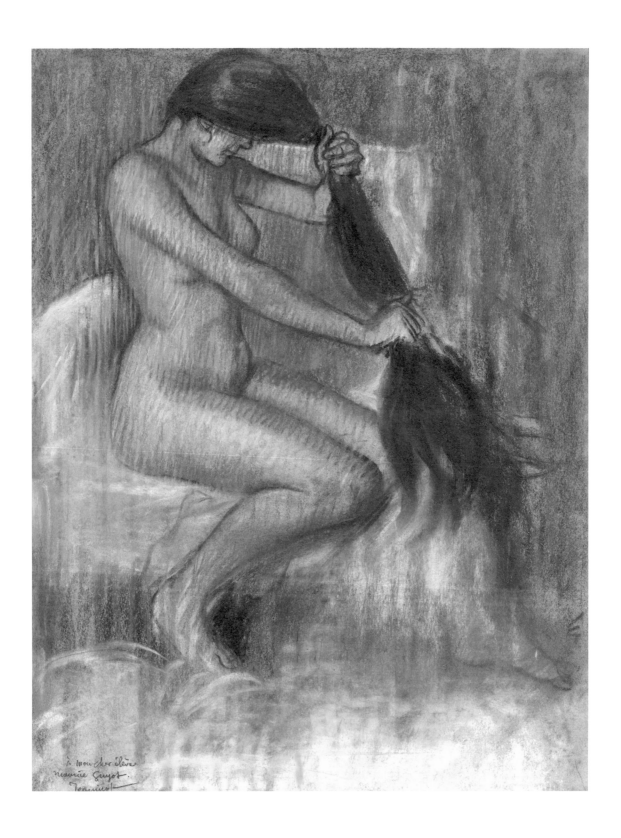

JEANNIOT, Pierre-Georges *Woman Combing Her Hair / Femme se peignant* 1890–92

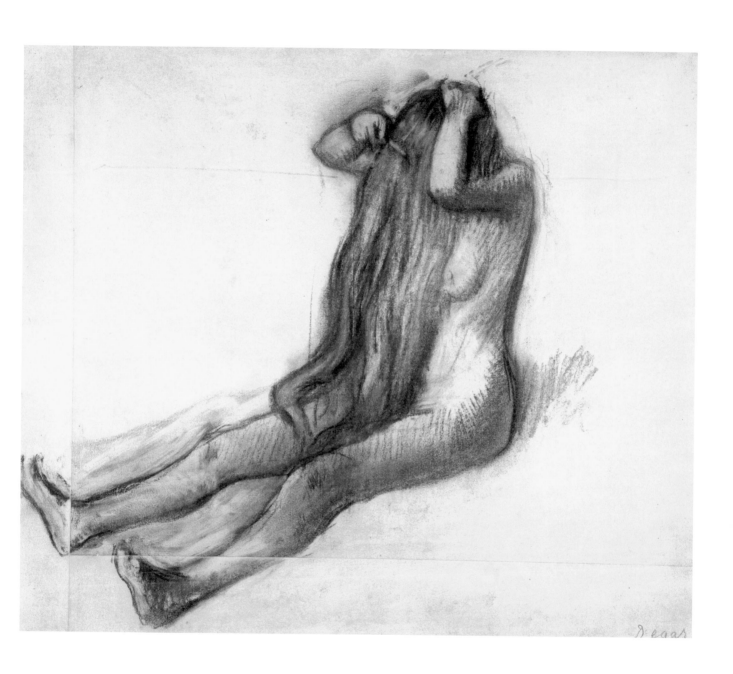

DEGAS, Edgar *Nude Seated on the Floor Combing Her Hair / Femme nue, assise par terre, se peignant* 1886–90 71

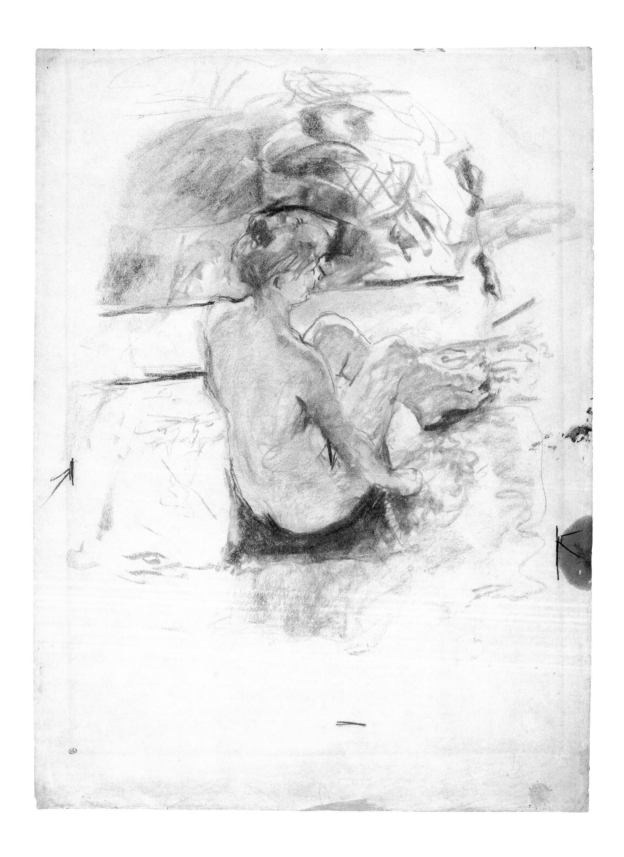

VUILLARD, Édouard *Seated Nude Model, Seen from Behind / Modèle féminin nu, assis de dos* c. 1900

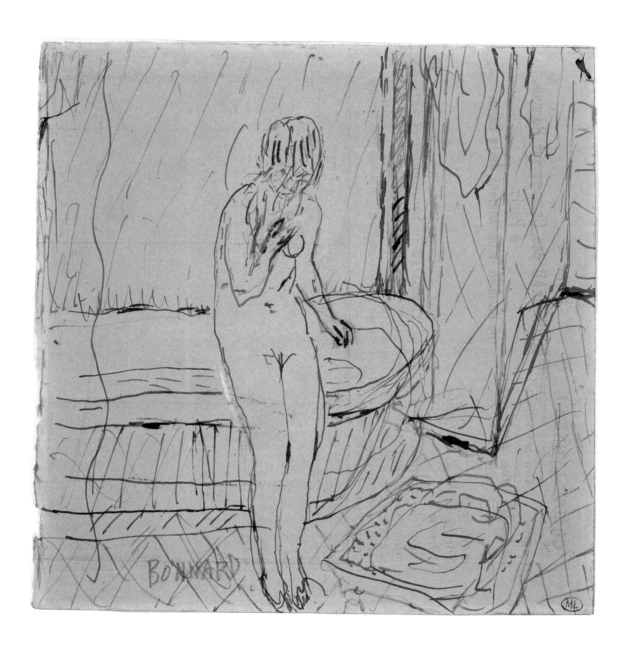

BONNARD, Pierre *Nude Leaning against a Tub, Bathmat at Her Feet /*

Femme nue devant une baignoire, à ses pieds, un tapis de bain 1933

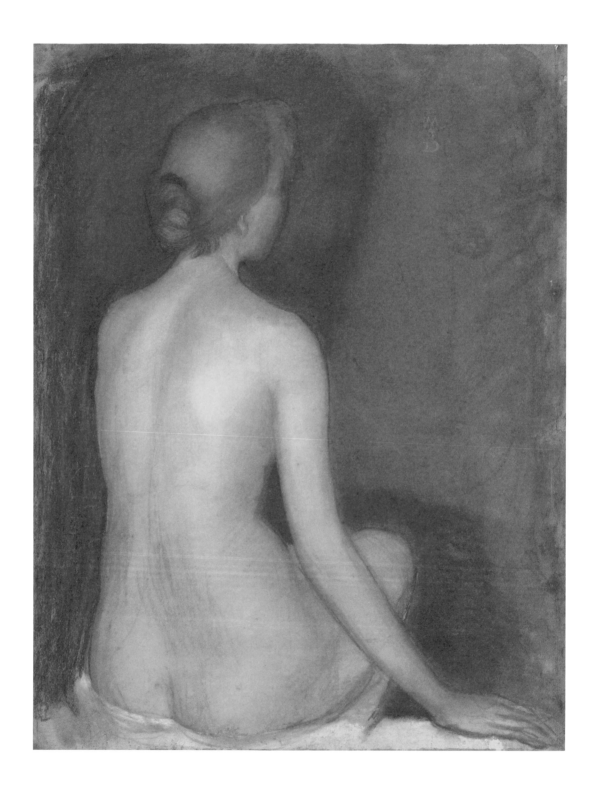

DENIS, Maurice *Nude Seen from Behind, Turned to the Right* / *Femme nue, vue de dos, tournée vers la droite* 1891

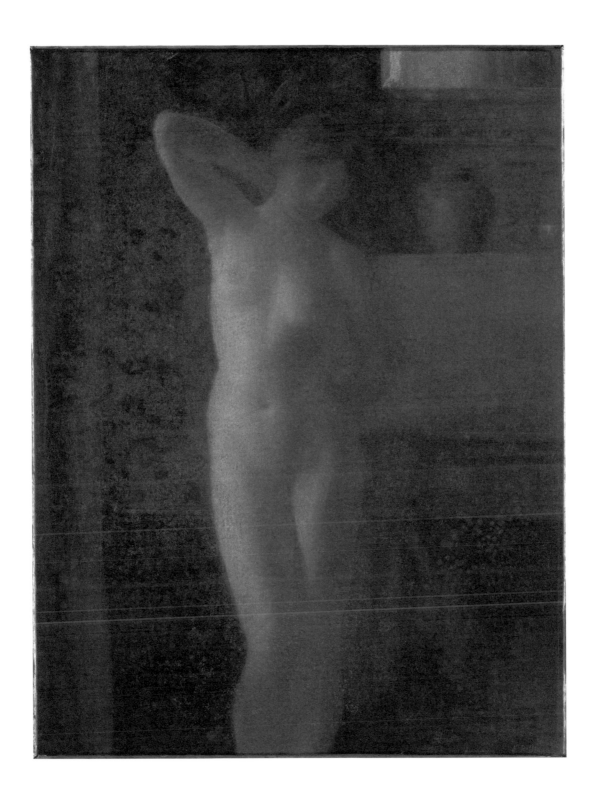

MENARD, Émile-René *Study of a Nude in an Interior / Étude de nu dans un intérieur* c.1890 75

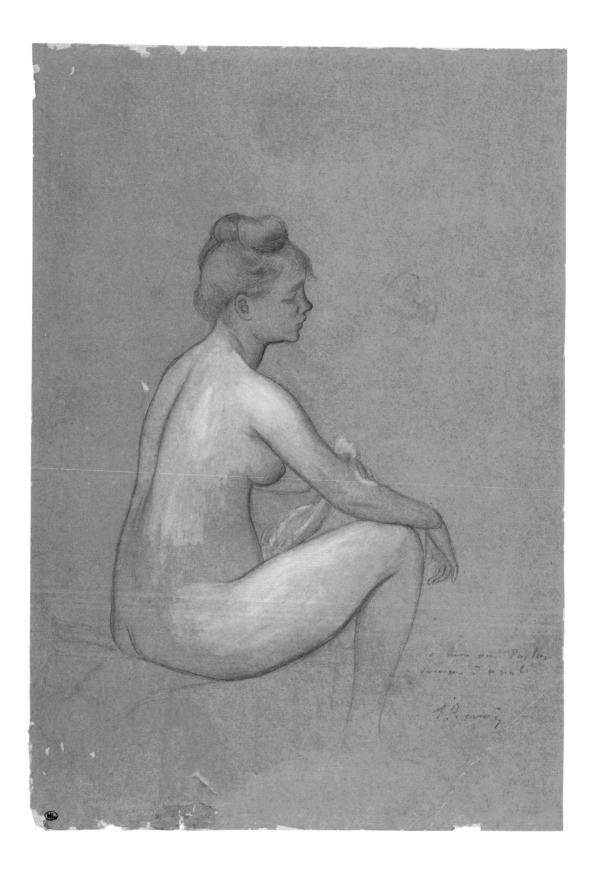

76 **RENOIR**, Pierre-Auguste *Seated Bather Drying Her Arms / Baigneuse assise s'essuyant les bras* 1887

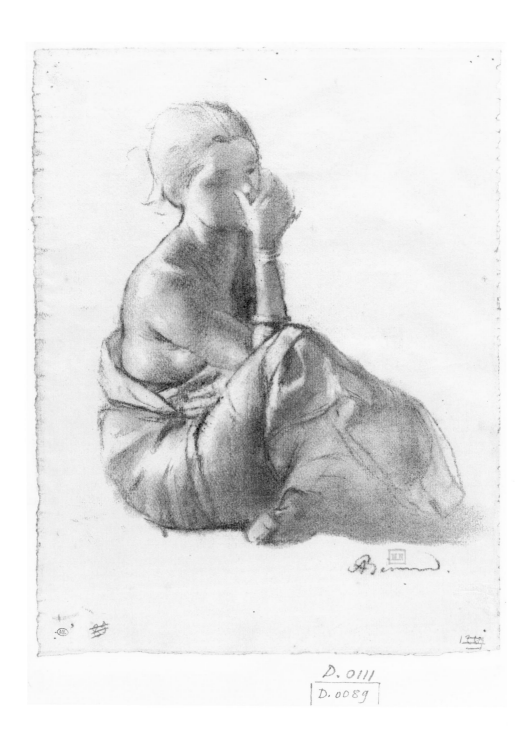

D. 0111
D. 0089

BESNARD, Albert *Seated Girl with Nude Torso and Legs Folded, in Right Three-Quarter View /*
Jeune fille assise, poitrine nue, jambes repliées, de trois quarts à droite 1872

THE PRIVATE REALM

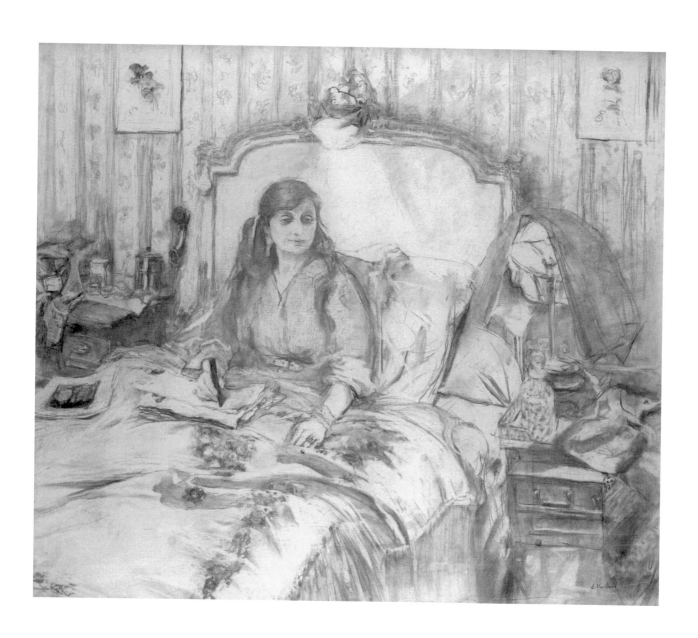

VUILLARD, Édouard *Portrait of the Countess Anna de Noailles / Portrait de la Comtesse Anna de Noailles* 1931

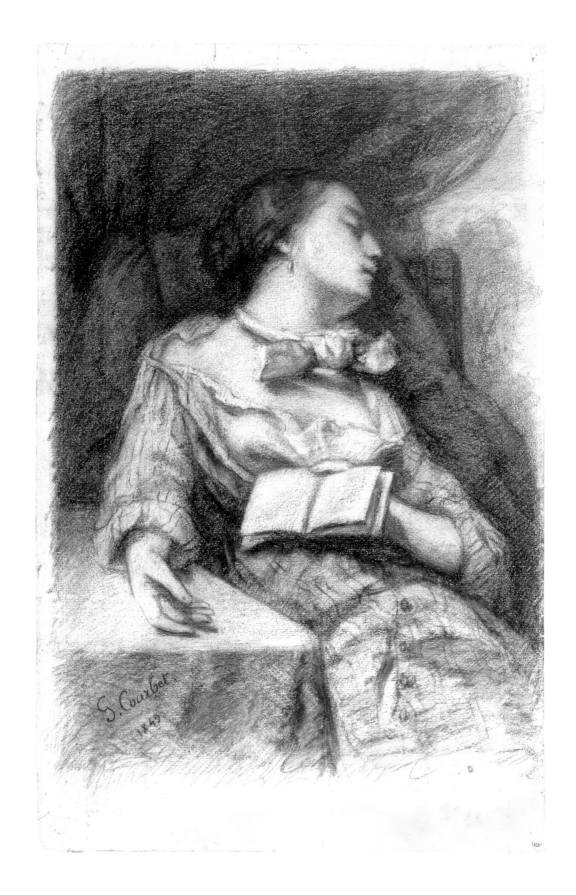

COURBET, Gustave *Seated Woman Sleeping and Holding a Book, Right Hand Resting on a Table /*

Femme assise, endormie, tenant un livre, la main droite sur la table 1849

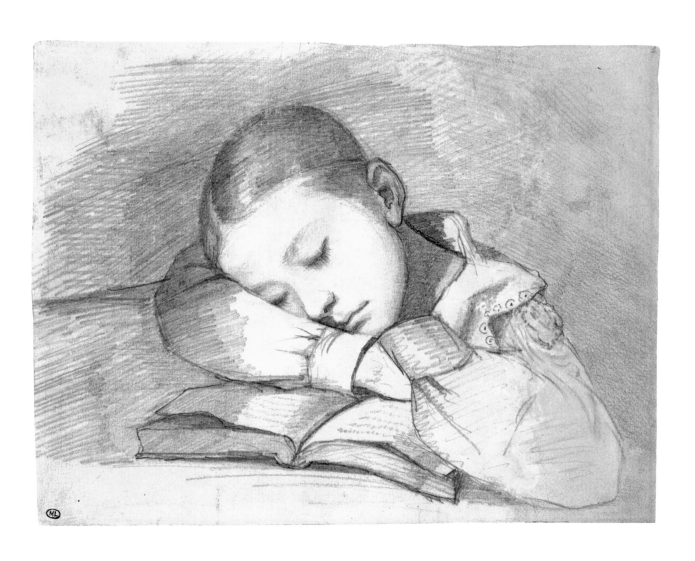

COURBET, Gustave *Portrait of the Artist's Young Sister Juliet, Asleep /*
Portrait de sa sœur Juliette Courbet enfant, dormant 1841

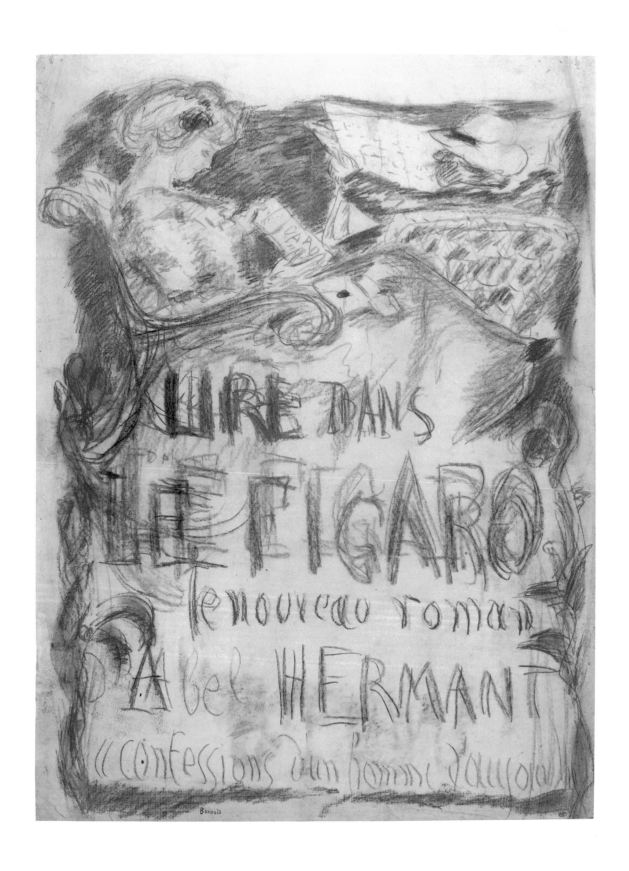

BONNARD, Pierre *Sketch for a newspaper advertisement for "Confession d'un homme d'aujourd'hui" by Abel Hermant,*
for Le Figaro / *Projet d'affiche pour* Le Figaro : « Confession d'un homme d'aujourd'hui » d'Abel Hermant c. 1903

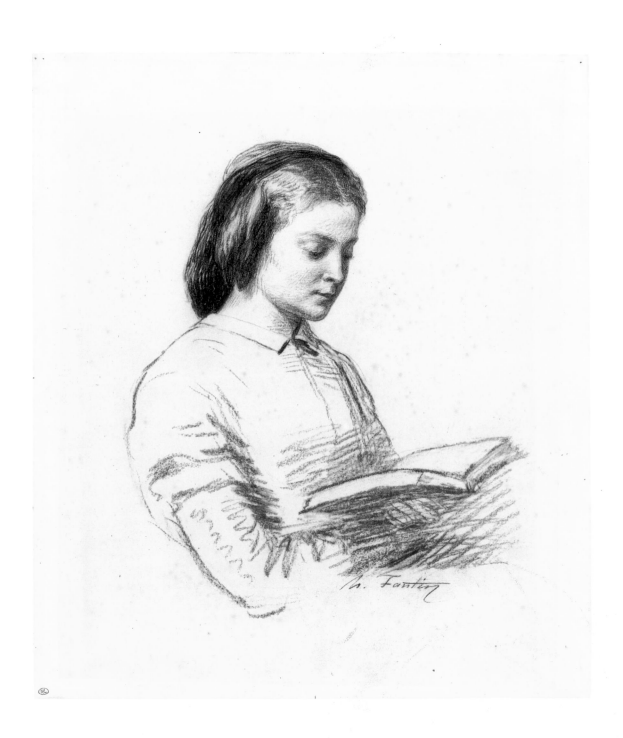

FANTIN-LATOUR, Henri *Bust of a Woman Reading, in Three-Quarter View / Femme en buste, de trois quarts, lisant* 1861 83

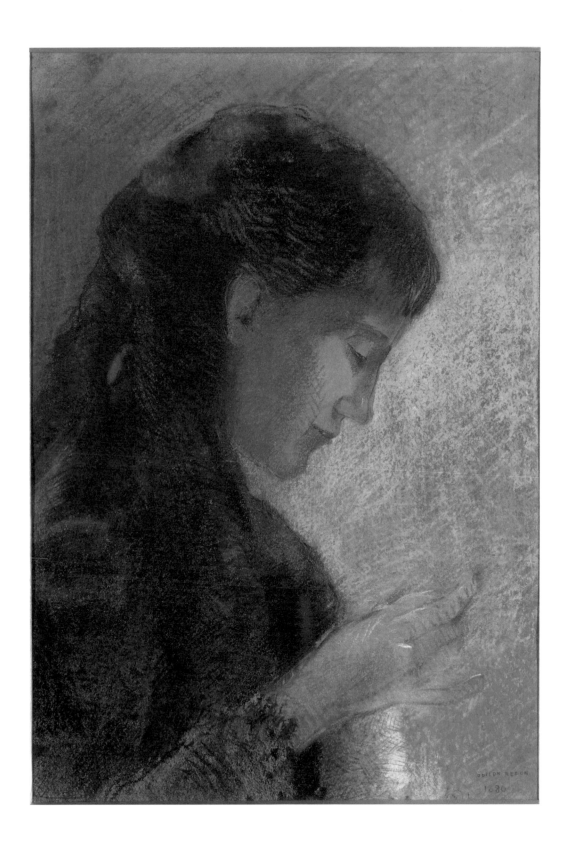

84 **REDON**, Odilon *Madame Redon Embroidering, in Profile / Portrait de Madame Redon brodant, vue de profil* 1880

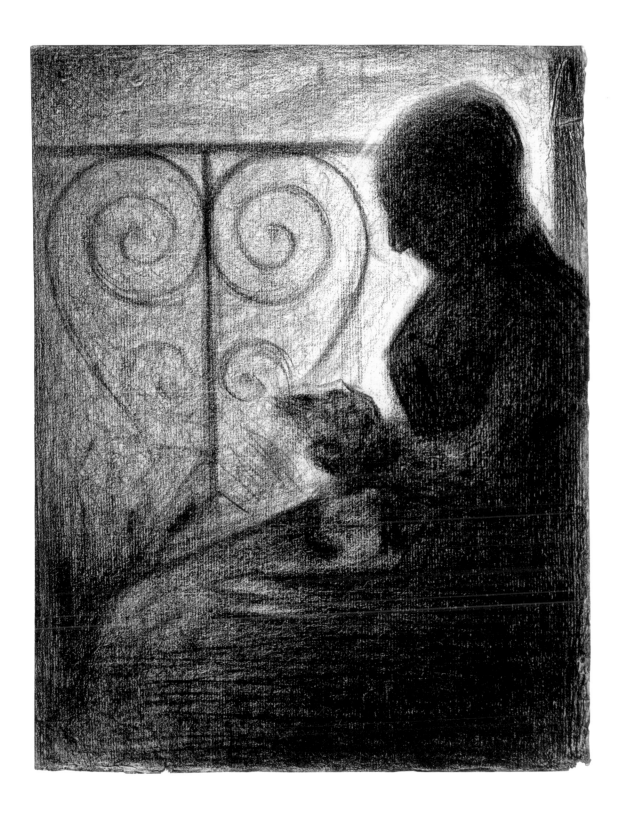

SEURAT, Georges *At the Balcony / Devant le balcon* 1883

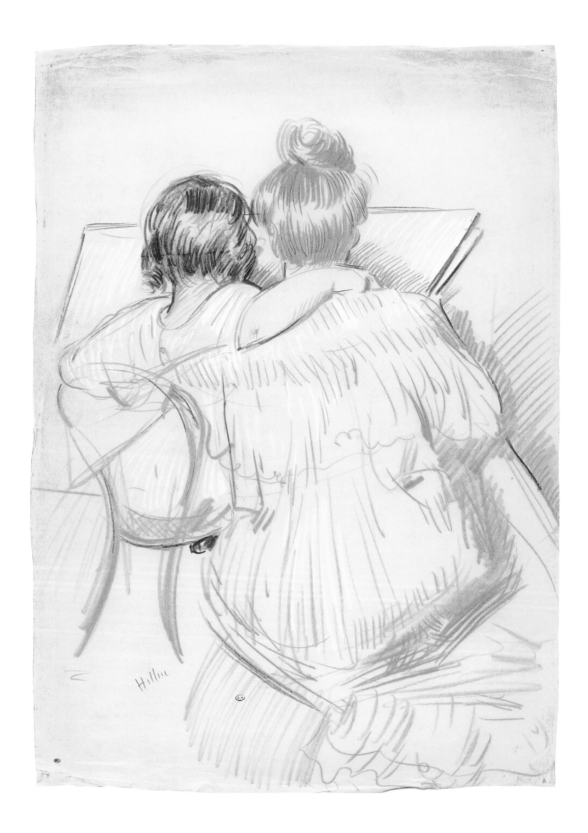

HELLEU, Paul *Paulette Sitting in a Chair, Seen from Behind* / *Paulette, assise sur une chaise, de dos* 1903

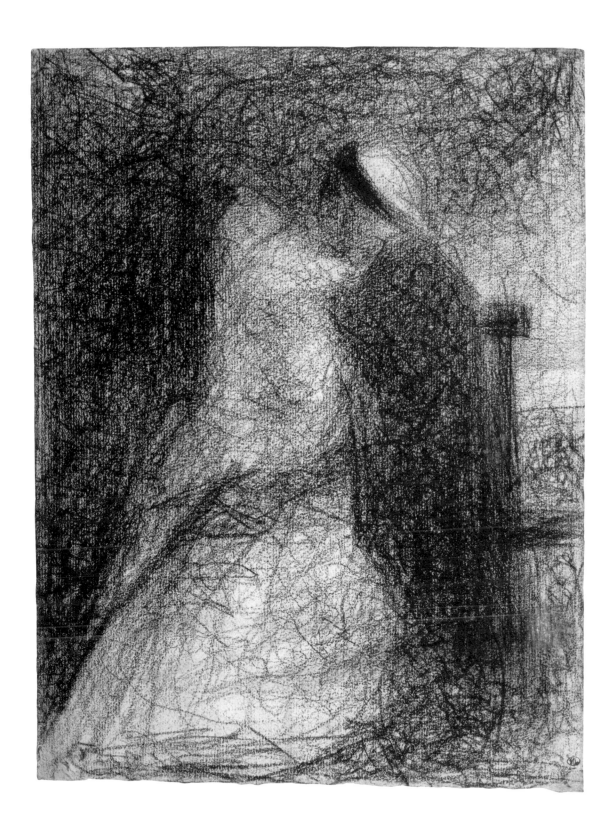

SEURAT, Georges *Seated Nursemaid Holding Her Infant / Nourrice assise, tenant son poupon* 1881–82

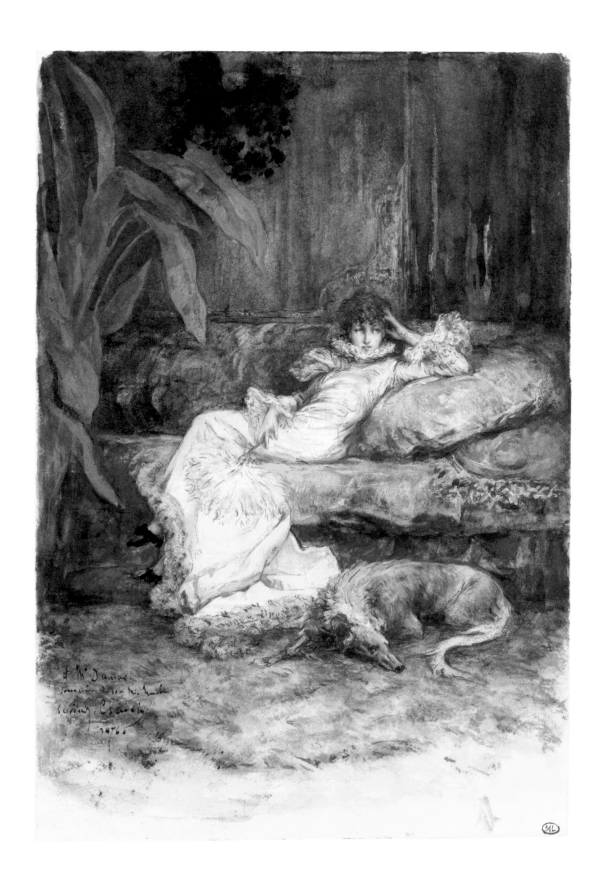

CLAIRIN, Georges *Portrait of Sarah Bernhardt Reclining on a Couch /*
Portrait de Sarah Bernhardt, à demi-étendue sur un canapé 1876

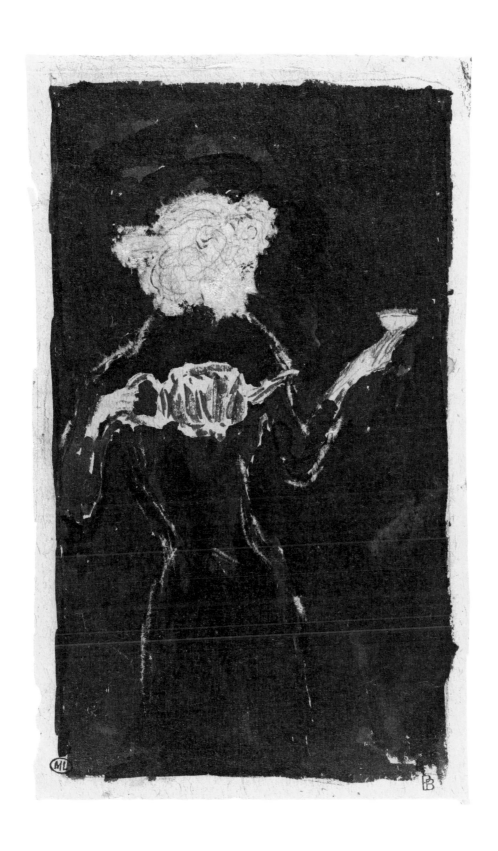

BONNARD, Pierre *Knee-Length View of a Woman in Right Profile, Carrying a Teapot /*
Femme vue à mi-jambes, de profil à droite, portant une théière 1900

BLANCHE, Jacques Émile *Young Women in White / Jeunes femmes en blanc* 1888

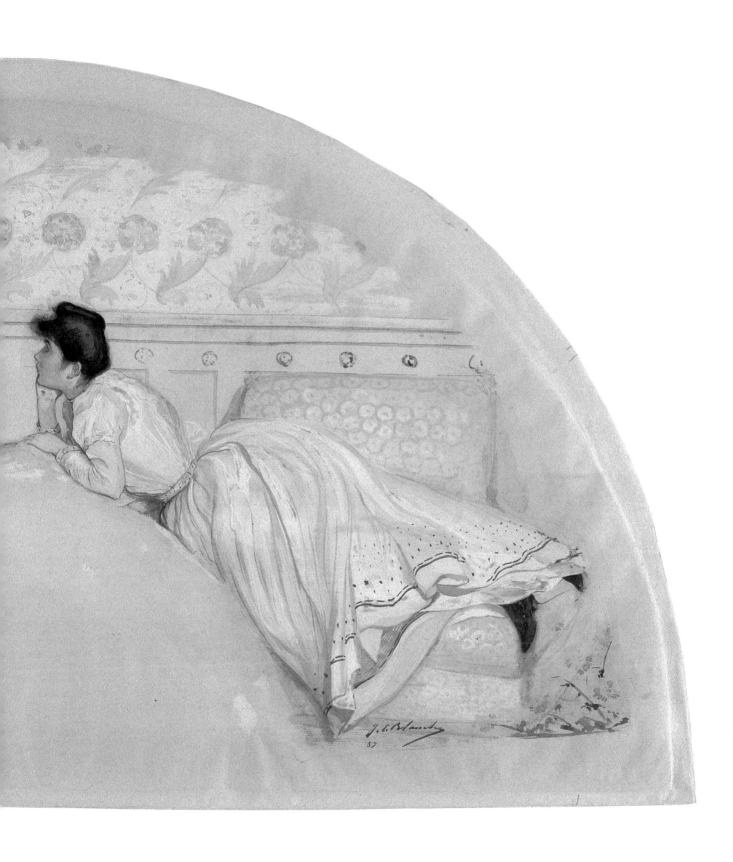

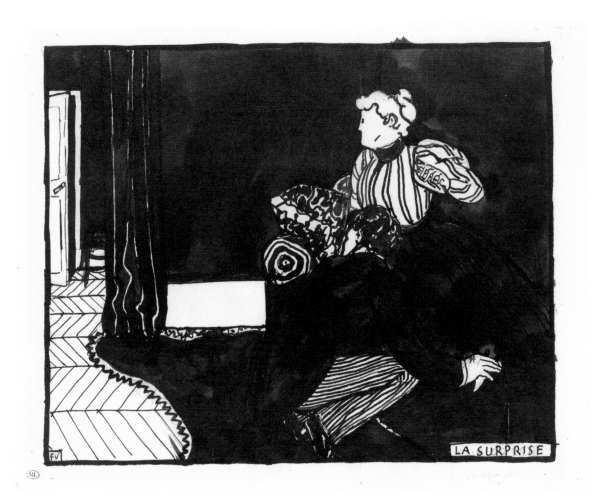

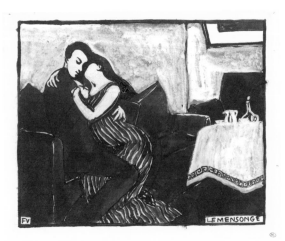

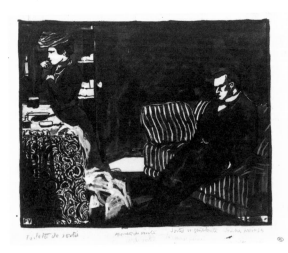

VALLOTTON, Félix Édouard (top) *Intimacy: Surprise | Les intimités : La surprise* 1897; (bottom left) *Initmacy: The Lie |*
Les intimités : Le mensonge 1897; (bottom right) *Intimacy: Dressing to Go Out | Les intimités : La toilette de sortie* 1897–98

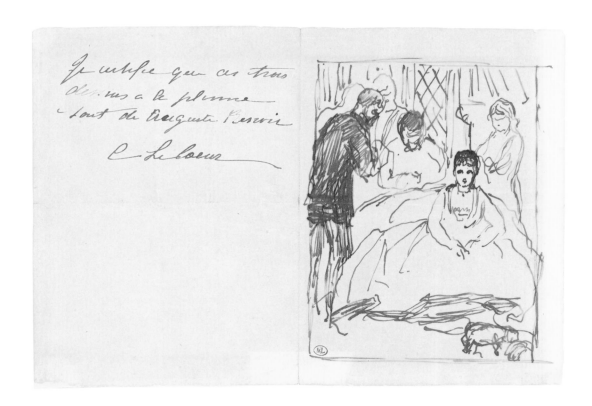

RENOIR, Pierre-Auguste *Woman Seated in an Interior, Surrounded by Figures /*

Femme assise dans un intérieur, entourée de personages c. 1875

93

THE PUBLIC REALM

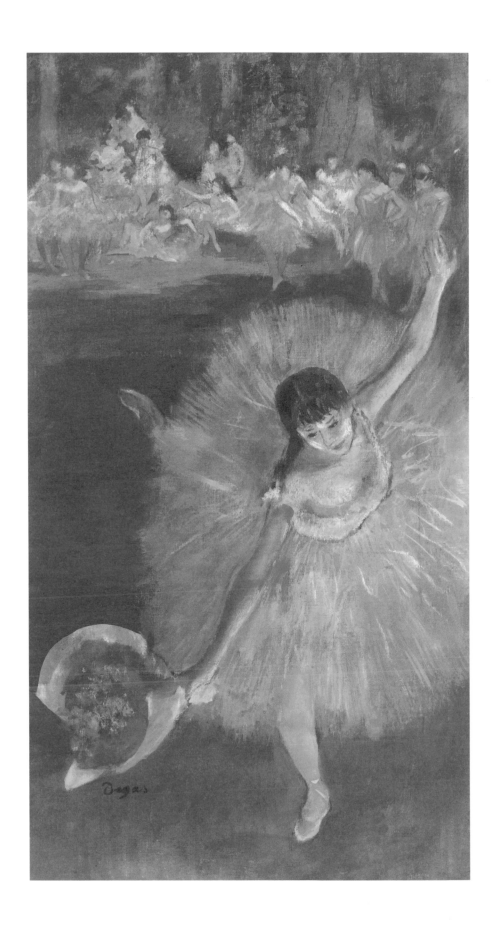

DEGAS, Edgar *The End of the Arabesque (Dancer Bowing) | Fin d'arabesque* ou *Danseuse saluant* 1876–77

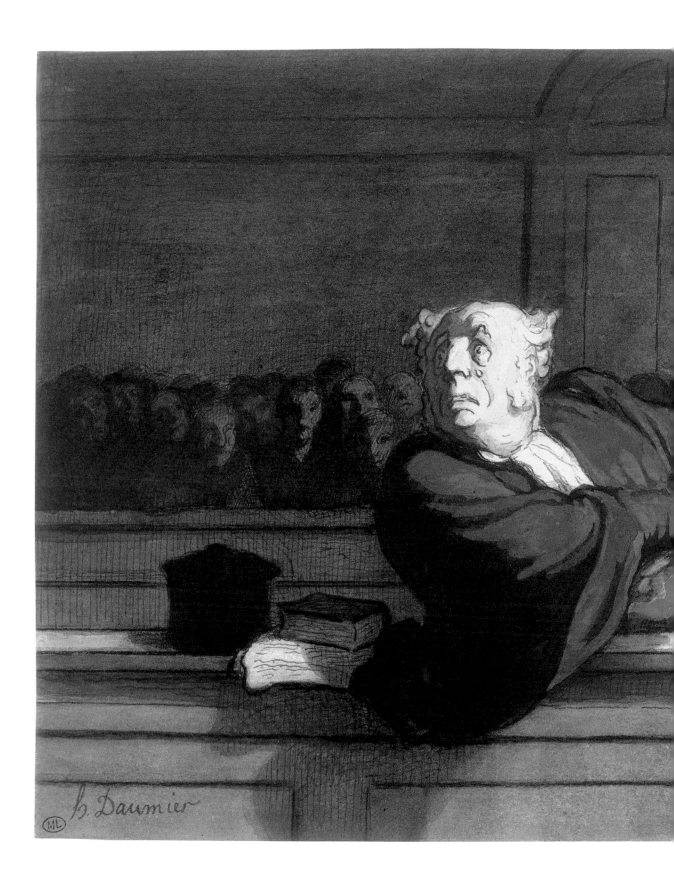

DAUMIER, Honoré *The Defense Attorney / Le Défenseur* 1862–65

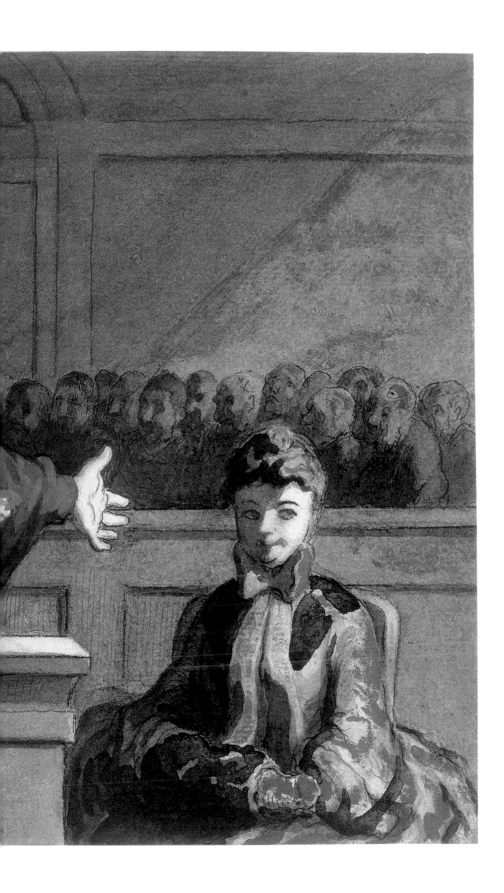

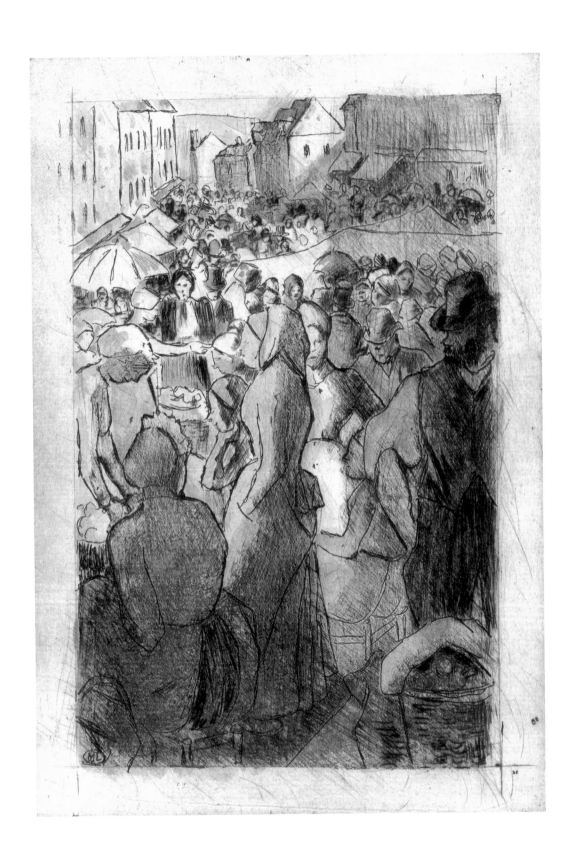

PISSARRO, Camille *Market in Gisors | Marché de Gisors* 1895

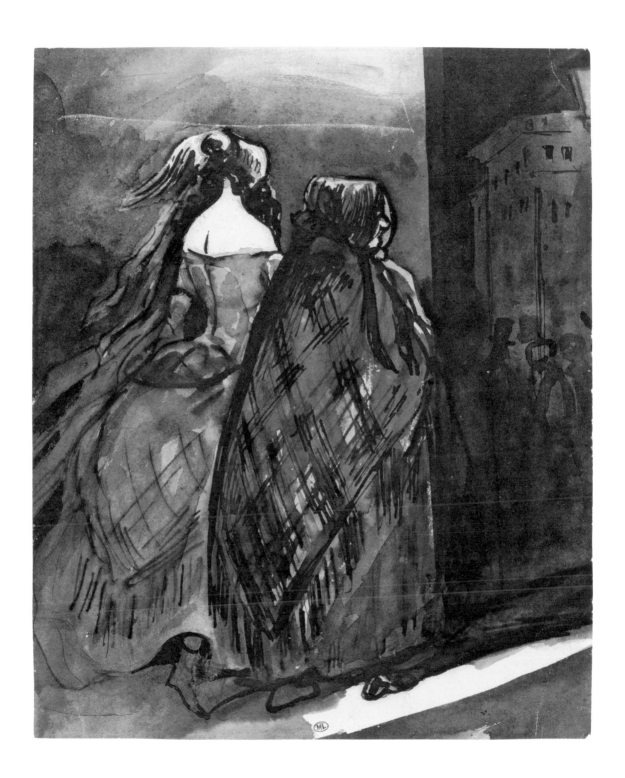

GUYS, Constantin *Young Woman with Her Chaperone / Jeune femme et sa Duègne* c. 1860

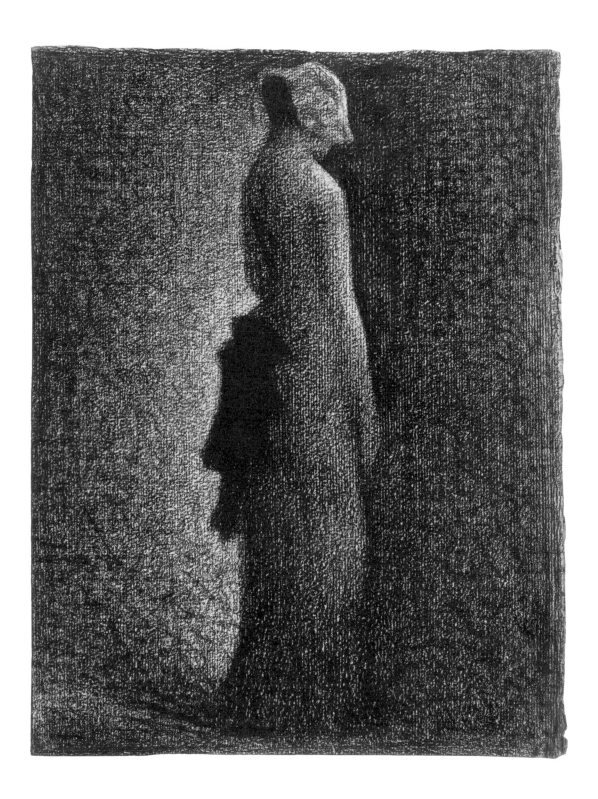

SEURAT, Georges *The Black Bow / Le nœud noir* c. 1882

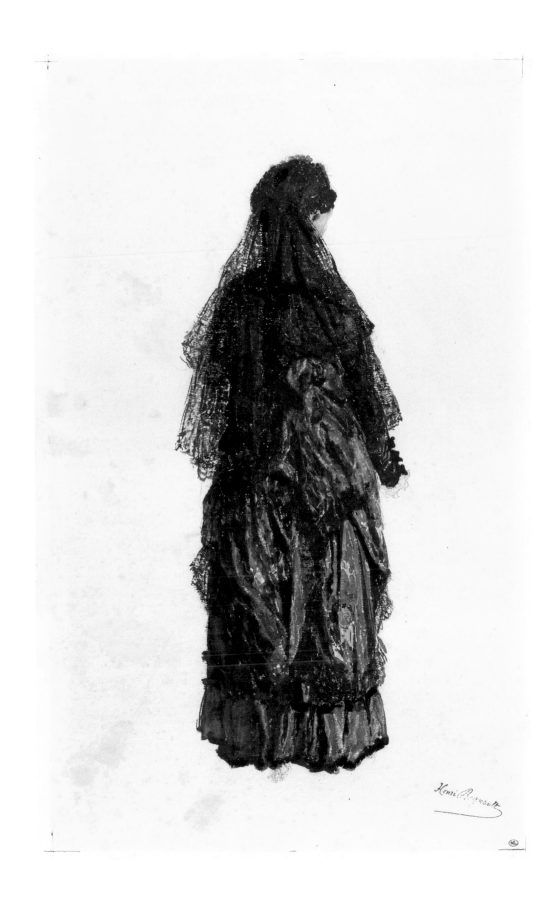

REGNAULT, Henri *Woman of Madrid (The Countess de Barck Seen from Behind)* /
La Madrilène, Comtesse de Barck, vue de dos 1869

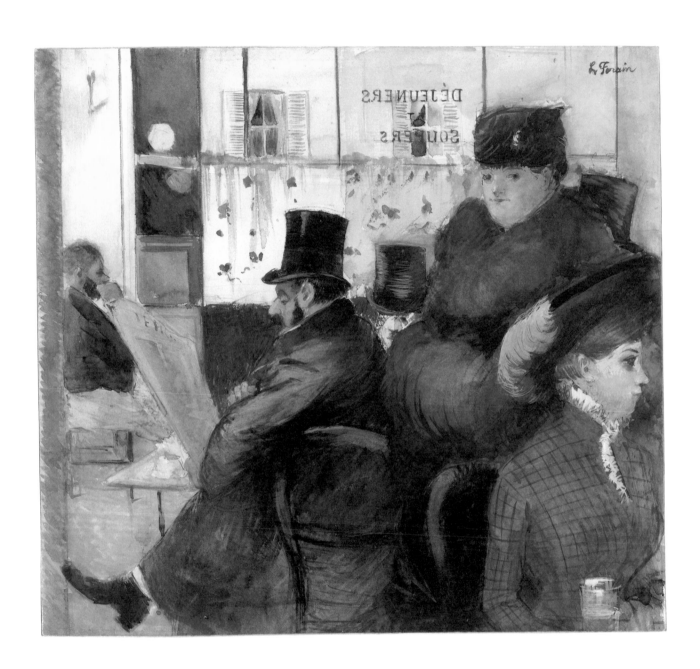

FORAIN, Jean-Louis *At the Nouvelle Athènes / Au café de la Nouvelle Athènes* 1885–90

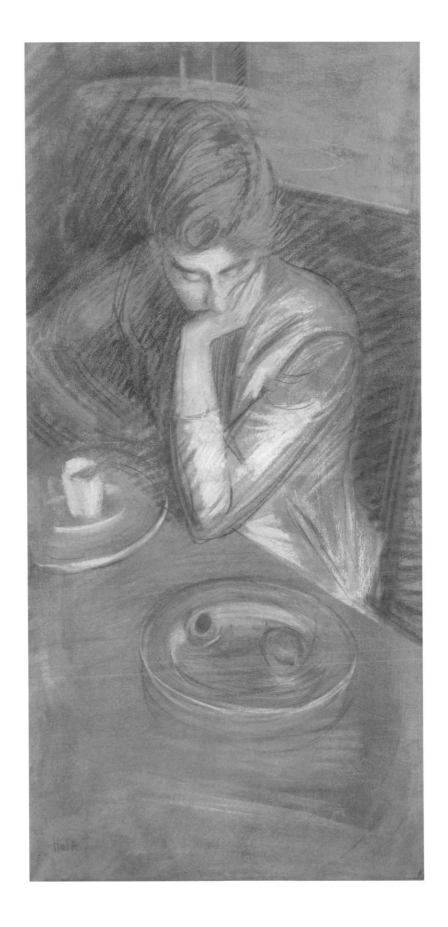

HELLEU, Paul *Woman Leaning on a Table* / *Femme accoudée à une table* 1889

TOULOUSE-LAUTREC, Henri de *The Milliner (Mademoiselle Le Margouin at Madame Renée Vert's)* /
La Modiste : mademoiselle Le Margouin chez madame Renée Vert 1893

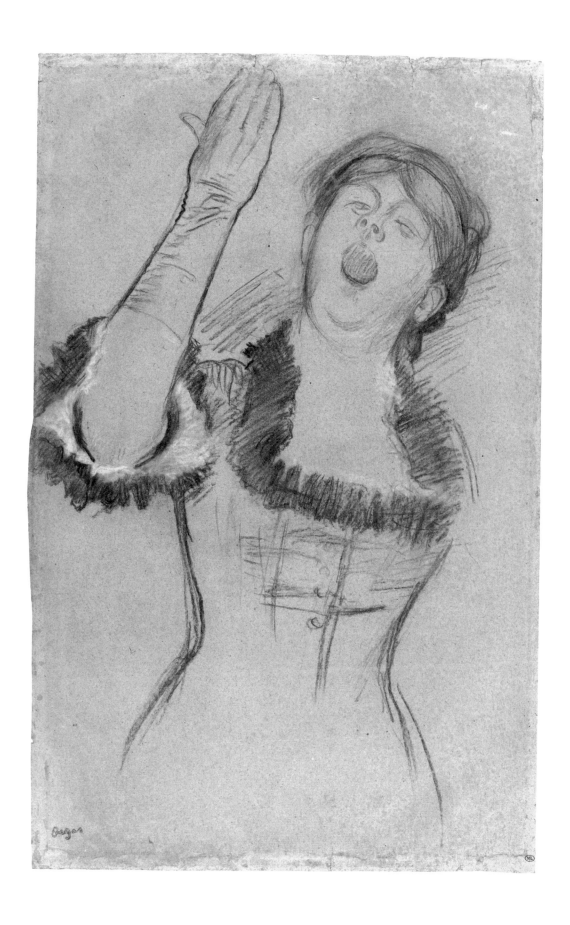

DEGAS, Edgar *Bust of a Cabaret Singer / Chanteuse de café-concert, en buste* 1878

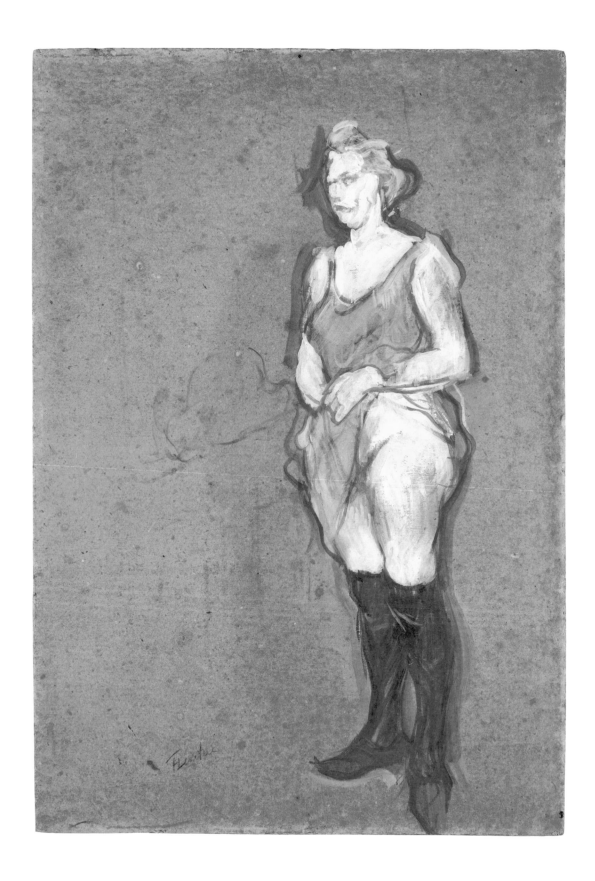

TOULOUSE-LAUTREC, Henri de *Blonde Madam / Femme de maison blonde* 1894

TOULOUSE-LAUTREC, Henri de *Réjane Wearing a Riding Hat in "Madame Sans-Gêne" /*
Réjane, coiffée d'un chapeau d'amazone, dans « Madame Sans-Gène » 1893

TOULOUSE-LAUTREC, Henri de *Yvette Guilbert, Arms Fallen to Her Sides /*
Yvette Guilbert, les deux bras tombant le long du corps 1894

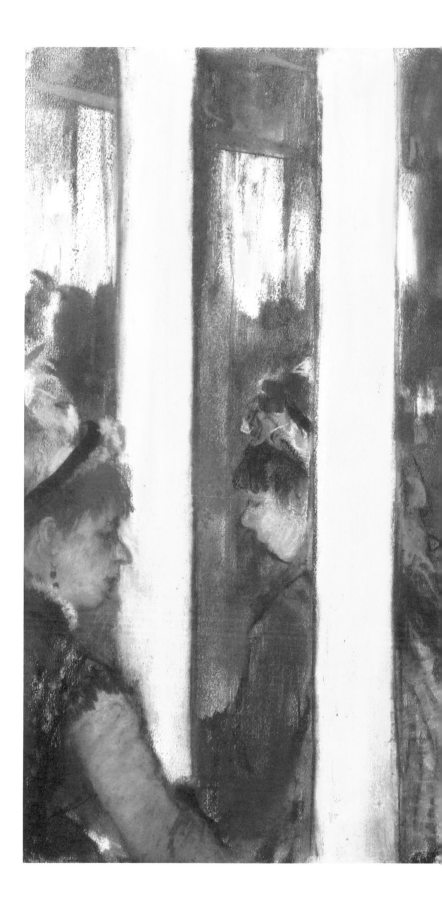

DEGAS, Edgar *A Café on Boulevard de Montmartre / Un café boulevard Montmartre* 1877

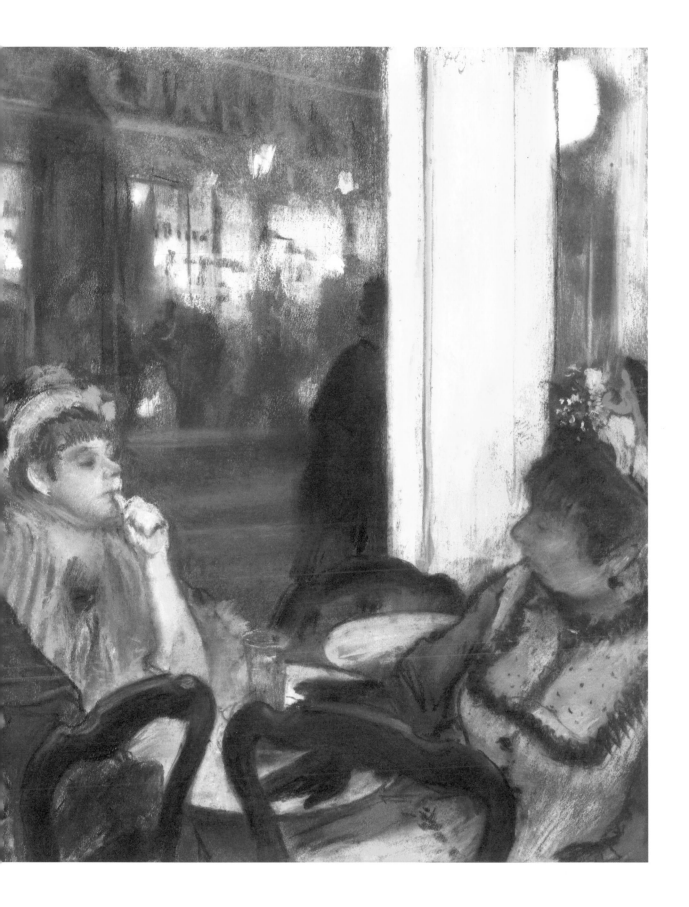

BEYOND THE CITY

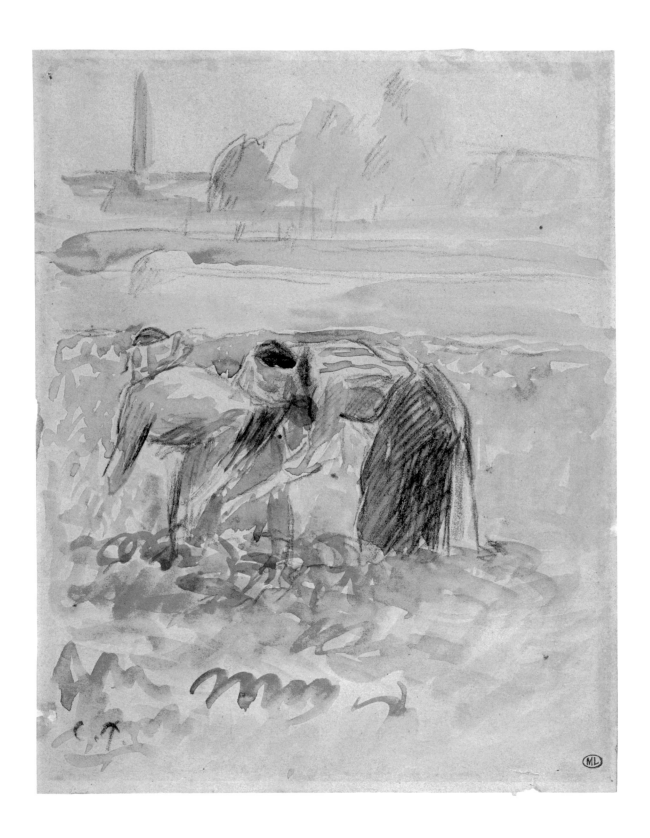

PISSARRO, Camille *Harvesting Peas / La cueillette des pois* 1885

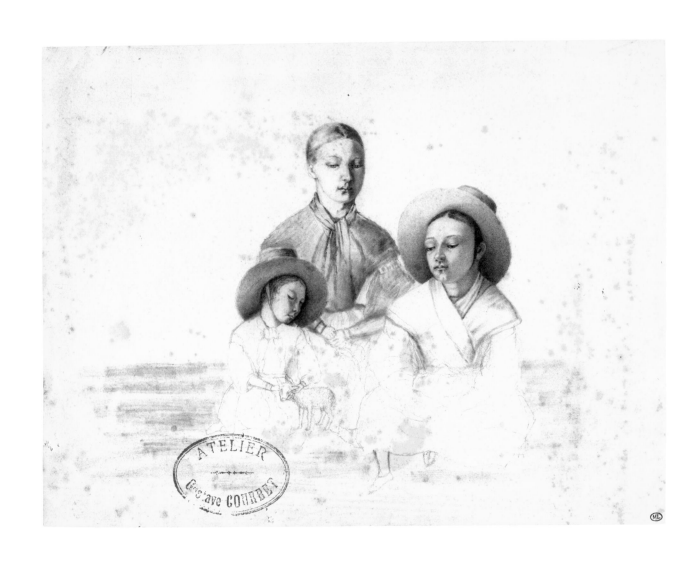

COURBET, Gustave *Portrait of a Woman Surrounded by Two Girls, One Holding a Lamb /*
Portrait d'une femme entourée de deux fillettes dont une qui tient un agneau 1840

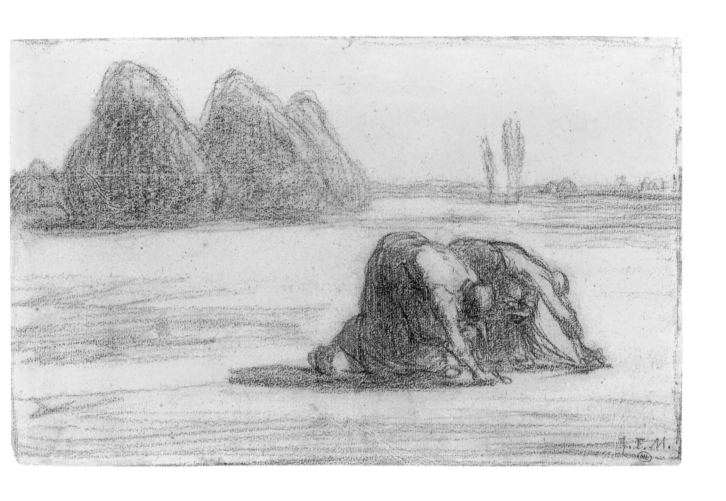

MILLET, Jean-François *The Gleaners / Les Glaneuses* 1850–51

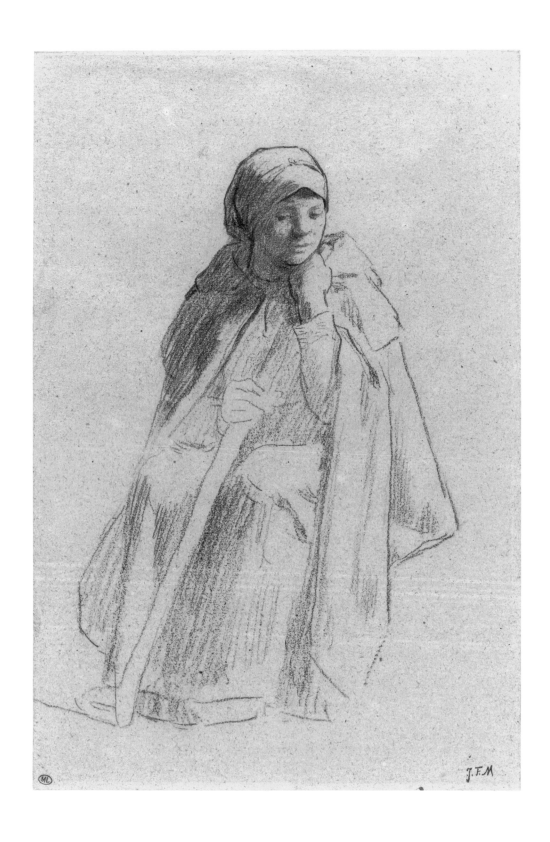

MILLET, Jean-François *Seated Shepherdess Wearing a Cloak, Right Hand Holding a Staff /*

Bergère assise, couverte d'un manteau, un bâton dans la main droite 1851–52

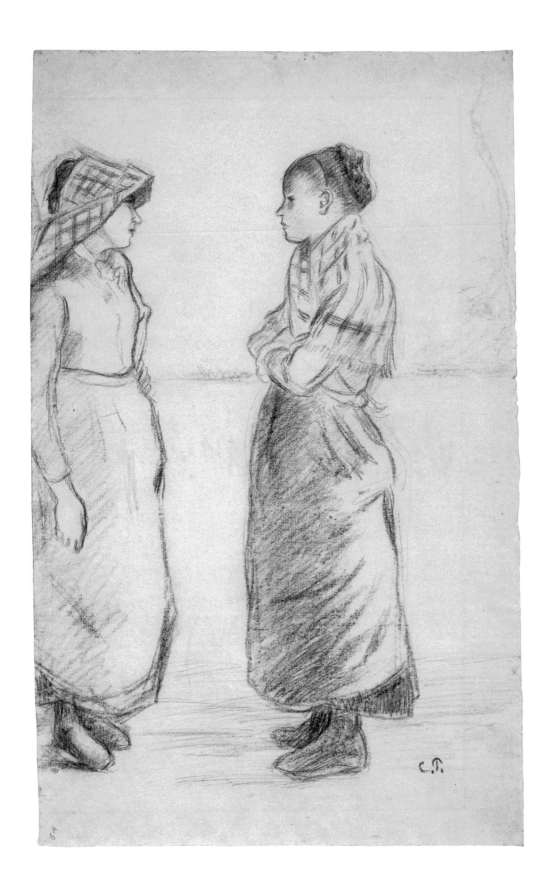

PISSARRO, Camille *Study for Two Women Chatting / Étude pour la causette* 1892

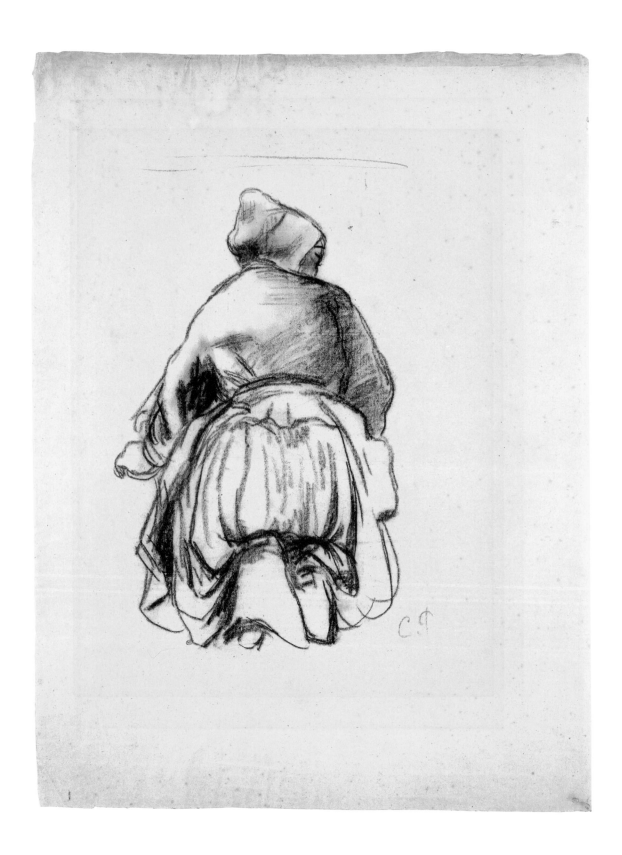

PISSARRO, Camille *Kneeling Peasant Woman Seen from Behind | Paysanne à genoux, vue de dos* 1870

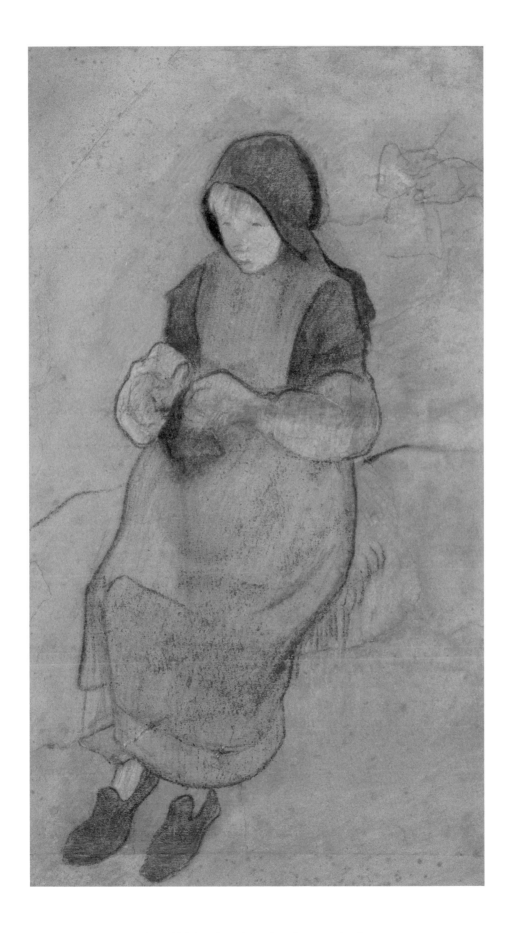

GAUGUIN, Paul *The Little Swineherd Seated, Knitting / La petite gardeuse de porcs assise tricotant* 1889

1887 Emile Bernard

BERNARD, Émile *Breton Woman in Headdress / Bretonne en grande coiffe* 1887

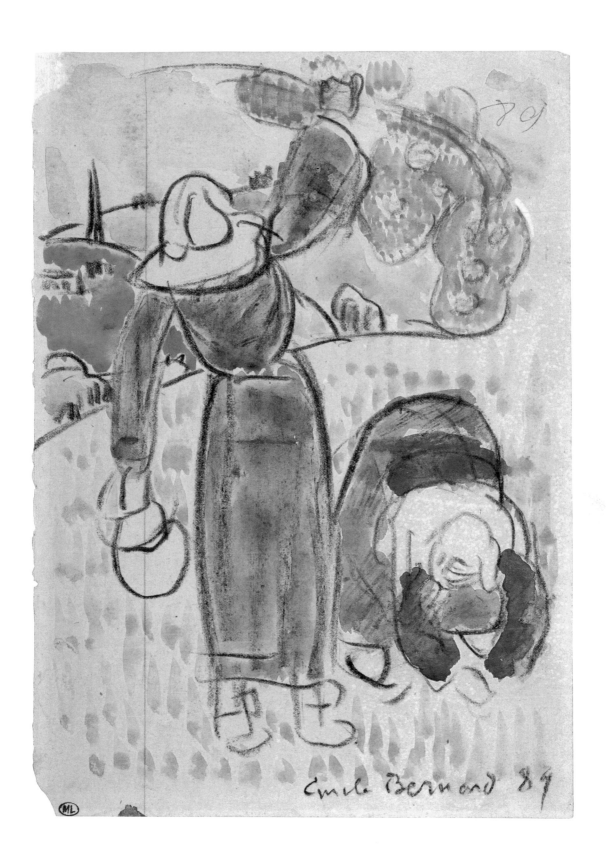

BERNARD, Émile *Breton Peasant Women in a Field / Paysannes bretonnes dans un champ* c. 1889

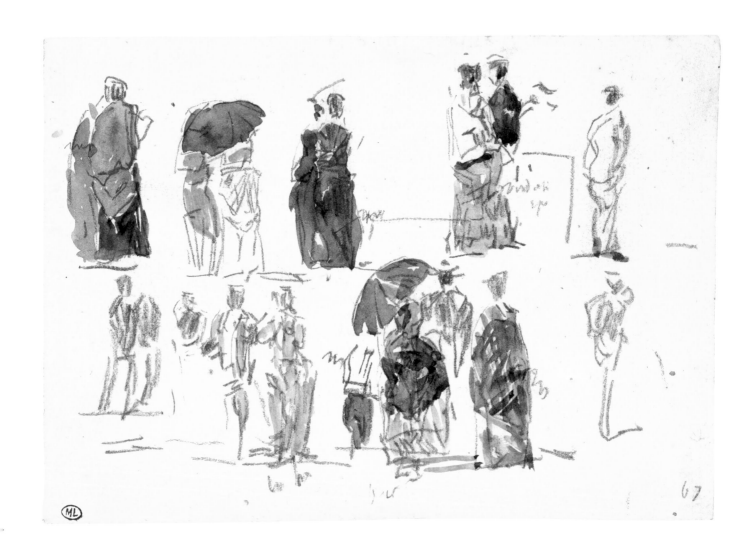

BOUDIN, Eugène *Various Groups of People / Différents groupes de personnes* 1867

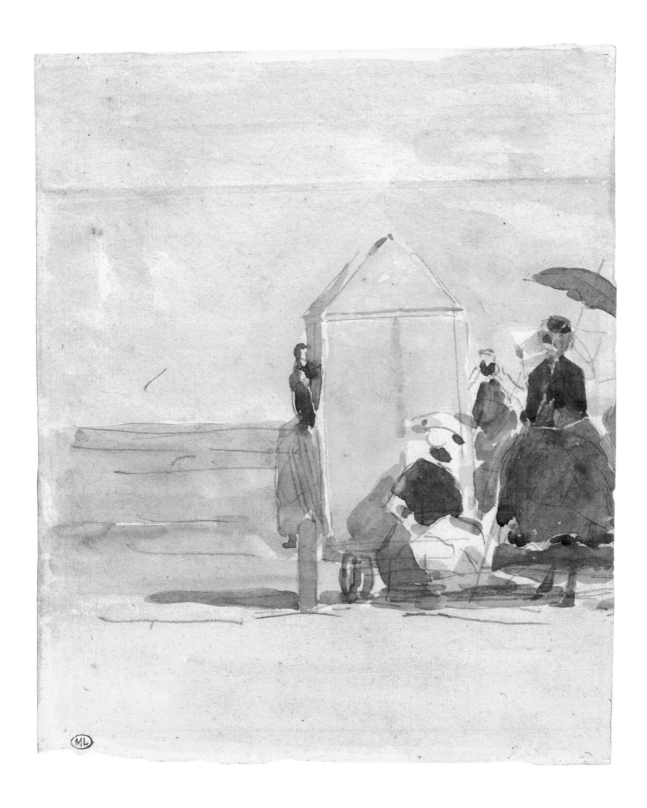

BOUDIN, Eugène *Beach Scene / Scène de plage* c. 1865

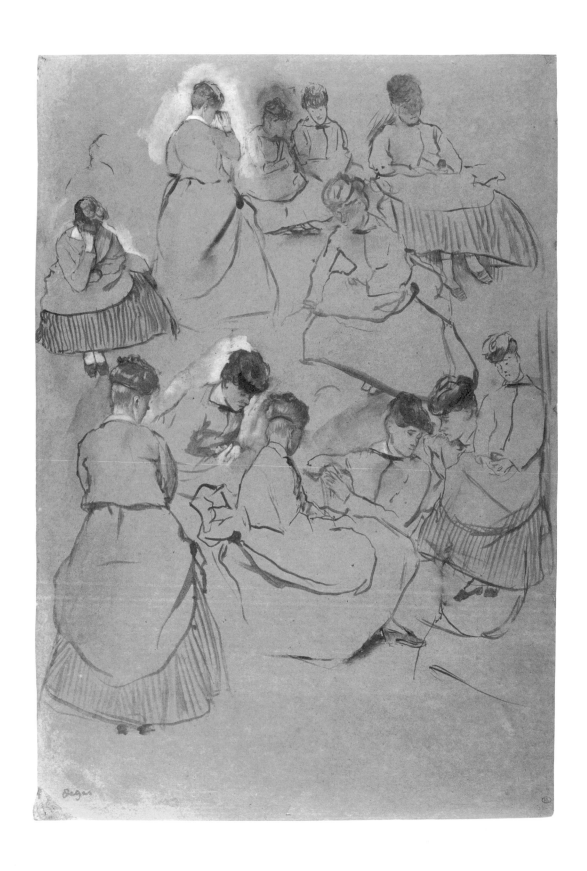

DEGAS, Edgar *Twelve Studies for Women Dressed in Second Empire Style /*
Douze études de femmes en costumes du second Empire 1866–68

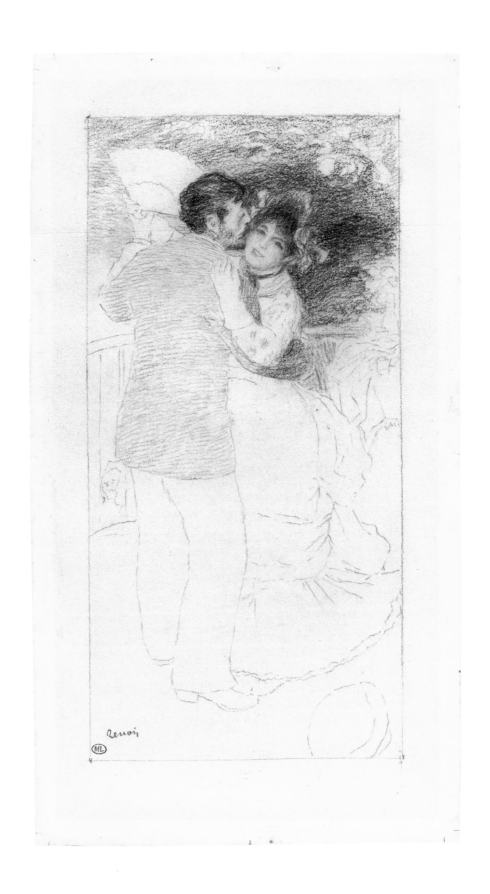

RENOIR, Pierre-Auguste *The Country Dance / La Danse à la campagne* 1882

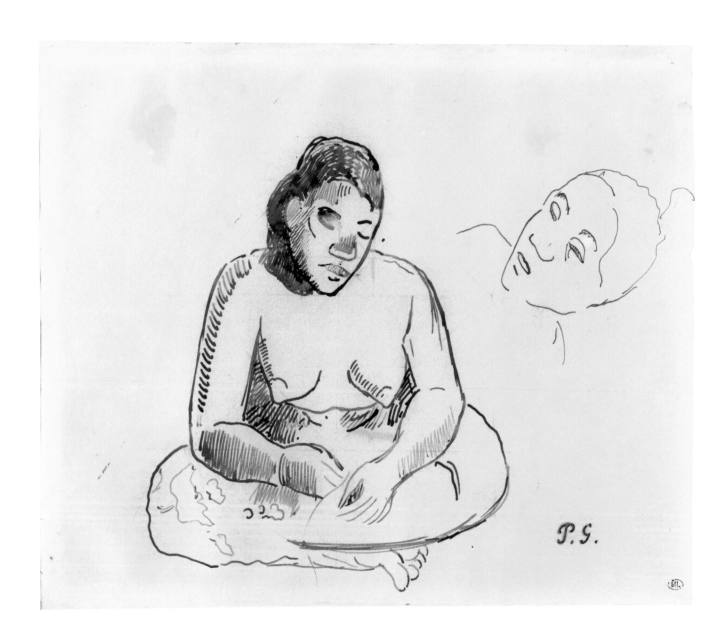

GAUGUIN, Paul *Seated Nude and Head Study | Femme nue assise et étude de tête* 1893

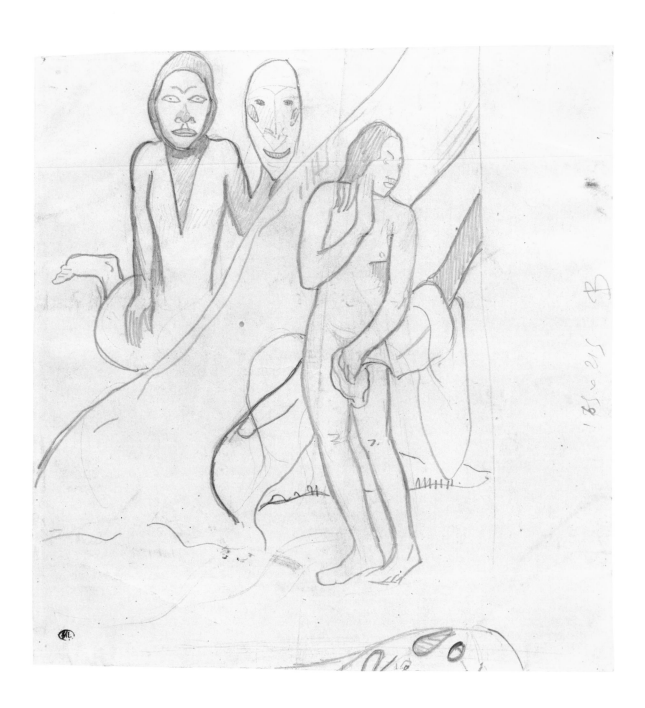

GAUGUIN, Paul *Standing Nude with Figure Emerging from Behind a Tree /*

Femme nue debout, et derrière un arbre, émerge un personage 1902

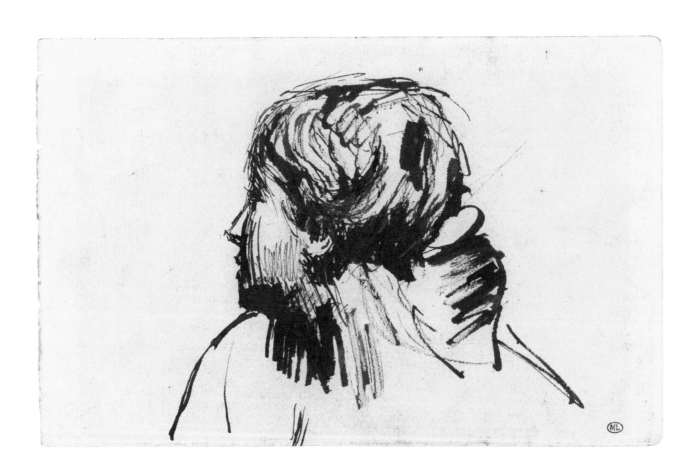

126 **BOURDELLE**, Émile-Antoine *Woman with a Chignon, Turned to the Left / Femme au chignon, tournée vers la gauche* 1927

LIST OF WORKS

All dimensions are unframed
height × width

AMAN-JEAN, Edmond-François
(Chevry, Seine-et-Marne 1858 –
Paris 1936)

*Bust of a Woman Turned to the Left,
Chin Resting on Her Hand / Femme,
vue en buste, tournée vers la gauche,
appuyant son menton sur sa main,*
1906
pastel on paper
52.8 × 41.7 cm
Paris, Musée d'Orsay (kept at
the Graphic Arts Department of
the Louvre), Maciet bequest,
1911, RF 39067
Photo: © RMN (Musée d'Orsay) /
Thierry Le Mage

*Standing Nude in Right Profile, Face
Front / Femme nue, debout, de profil
à droite, la tête de face,* 1906
pastel on paper
53 × 39.5 cm
Paris, Musée d'Orsay (kept at
the Graphic Arts Department of
the Louvre), RF 39065
Photo: © RMN (Musée d'Orsay) /
Thierry Le Mage

AMAURY-DUVAL, Eugène
(Paris 1808 – Paris 1885)

*Portrait of the Countess d'Etchégoyen
as a Young Woman / Portrait de la
Comtesse d'Etchégoyen, jeune,* 1867
charcoal with white highlights
on beige paper
55.3 × 45 cm
Paris, Musée d'Orsay (kept at
the Louvre), Gift of the Countess
d'Etchégoyen, 1933, RF 24066

Photo: © RMN (Musée d'Orsay) /
Thierry Le Mage

ANGRAND, Charles
(Criquetot-sur-Oucille 1854 –
Rouen 1926)

My Mother / Ma Mère, 1899
charcoal on light grey paper
with fixative
66 × 48 cm
Paris, Musée d'Orsay (kept at
the Graphic Arts Department of
the Louvre), Loudmer
donation, 1986, RF 41204
Photo: © RMN (Musée d'Orsay) /
Jean-Gilles Berizzi

BERNARD, Émile
(Lille 1868 – Paris 1941)

*Breton Woman in Headdress /
Bretonne en grande coiffe,* 1887
watercolour, brown ink, and
Indian ink with brush and pen
on paper
20 × 15.2 cm
Paris, Musée d'Orsay (kept at
the Graphic Arts Department of
the Louvre), Purchased by the
Musées Nationaux, 1942,
RF 39112
Photo: © RMN (Musée d'Orsay) /
Michèle Bellot

*Breton Peasant Women in a Field /
Paysannes bretonnes dans un
champ,* c. 1889
charcoal and watercolour on
beige paper
21.8 × 15.6 cm
Paris, Musée d'Orsay (kept at
the Graphic Arts Department of
the Louvre), Purchased by the
Musées Nationaux, 1942,
RF 39114

Photo: © RMN (Musée d'Orsay) /
Michèle Bellot

BESNARD, Albert
(Paris 1849 – Paris 1934)

*Seated Girl with Nude Torso and
Legs Folded, in Right Three-Quarter
View / Jeune fille assise, poitrine
nue, jambes repliées, de trois quarts
à droite,* 1872
charcoal and stumping on
paper
30 × 23.7 cm
Paris, Musée d'Orsay (kept at
the Graphic Arts Department of
the Louvre), Purchased from
the artist, 1922, RF 39169
Photo: © RMN (Musée d'Orsay) /
Jean-Gilles Berizzi

*Nude Seen from Behind with a
Peacock Feather, Head in Right
Profile / Femme nue, de dos, avec
une queue de paon, la tête de
profil à droite,* 1890
watercolour and black Conté
crayon on Bristol board
39 × 28.2 cm
Paris, Musée d'Orsay (kept at
the Graphic Arts Department of
the Louvre), Maciet bequest,
1911, RF 39147
Photo: © RMN (Musée d'Orsay) /
Jean-Gilles Berizzi

BLANCHE, Jacques Émile
(Paris 1861 – Offranville
1942)

*Young Women in White / Jeunes
femmes en blanc,* 1888
pencil, black ink, gouache, and
watercolour on paper
15.5 × 57.2 cm

Paris, Musée d'Orsay (kept at
the Graphic Arts Department of
the Louvre), Purchased 1980,
RF 41569
Photo: © RMN (Musée d'Orsay) /
Jean-Gilles Berizzi

BONNARD, Pierre
(Fontenay-aux-Roses 1867 –
Le Cannet 1947)

*Knee-Length View of a Woman in
Right Profile, Carrying a Teapot /
Femme vue à mi-jambes, de profil
à droite, portant une théière,* 1900
Indian ink wash and leadpoint
on paper
10 × 17 cm
Paris, Musée d'Orsay (kept at
the Graphic Arts Department of
the Louvre), Purchased 1979,
RF 37089
Photo: © RMN (Musée d'Orsay) /
Jean-Gilles Berizzi

*Sketch for a newspaper advertise-
ment for "Confession d'un homme
d'aujourd'hui" by Abel Hermant,
for Le Figaro / Projet d'affiche
pour Le Figaro : « Confession d'un
homme d'aujourd'hui » d'Abel
Hermant,* c. 1903
charcoal and red chalk on paper
55.5 × 41.3 cm
Paris, Musée d'Orsay (kept at
the Graphic Arts Department of
the Louvre), Gift of M. and
Mme Zadok, 1965, RF 39222
Photo: © RMN (Musée d'Orsay) /
Michèle Bellot

*Nude Leaning against a Tub,
Bathmat at Her Feet / Femme nue
devant une baignoire, à ses pieds,
un tapis de bain,* 1933

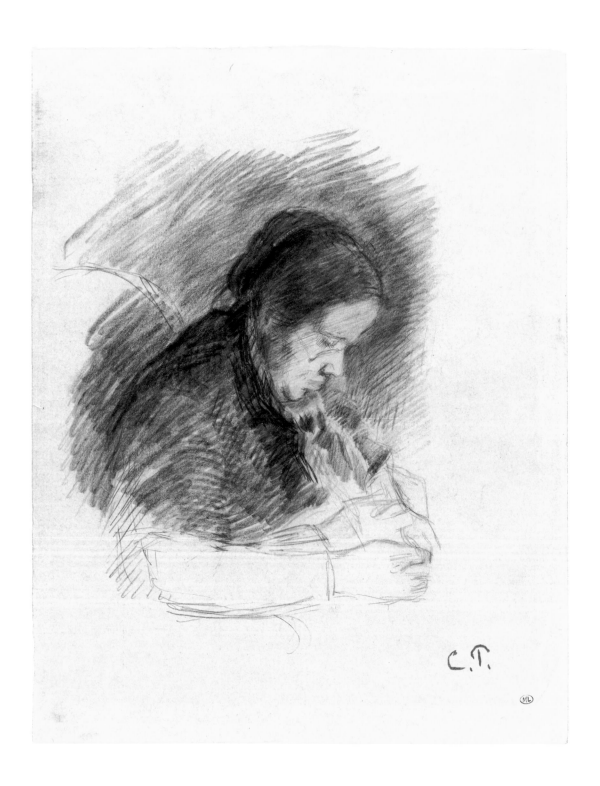

PISSARRO, Camille *Bust of an Old Woman Knitting / Vieille femme en buste tricotant* c. 1878

pen and brown ink and
leadpoint on paper
14.9 × 15 cm
Paris, Musée d'Orsay (kept at
the Graphic Arts Department of
the Louvre), Carle Dreyfus
bequest, 1953, RF 39200
Photo: © RMN (Musée d'Orsay) /
Michèle Bellot

BOUDIN, Eugène
(Honfleur 1824 – Deauville
1898)

Beach Scene | Scène de plage,
c. 1865
watercolour and leadpoint on
paper
18.6 × 15.6 cm
Paris, Musée d'Orsay (kept at
the Graphic Arts Department of
the Louvre), Purchased by the
Musée du Luxembourg, 1930,
RF 19420
Photo: © RMN (Musée d'Orsay) /
Jean-Gilles Berizzi

*Various Groups of People |
Différents groupes de personnes*,
1867
watercolour, black ink, and
leadpoint on paper
12.7 × 10.5 cm
Paris, Musée d'Orsay (kept at
the Graphic Arts Department of
the Louvre), Purchased by the
Musée du Luxembourg, 1930,
RF 19480
Photo: © RMN (Musée d'Orsay) /
Michèle Bellot

BOURDELLE, Émile-Antoine
(Montauban 1861 – Le Vésinet
1929)

*Isadora Duncan Dancing | Isadora
Duncan dansant*, c. 1910
pen and brown ink on paper
24 × 16 cm
Paris, Musée d'Orsay (kept at
the Graphic Arts Department of
the Louvre), Gift of Rhodia

Dufet Bourdelle, 1976, RF 36131
Photo: © RMN (Musée d'Orsay) /
Jean-Gilles Berizzi

*Amphora (Female Nude) |
Amphore : nu féminin*, 1927
leadpoint and pen and black ink
on paper
27 × 21 cm
Paris, Musée d'Orsay (kept at
the Graphic Arts Department of
the Louvre), Gift of Rhodia
Dufet Bourdelle, 1976, RF 36129
Photo: © RMN (Musée d'Orsay) /
Jean-Gilles Berizzi

*Woman with a Chignon, Turned to
the Left | Femme au chignon, tournée
vers la gauche*, 1927
black ink, brush, and pen on
paper
14 × 22 cm
Paris, Musée d'Orsay (kept at
the Graphic Arts Department of
the Louvre), Gift of Rhodia
Dufet Bourdelle, 1976,
RF 36130
Photo: © RMN (Musée d'Orsay) /
Jean-Gilles Berizzi

CARPEAUX, Carpeaux,
Jean-Baptiste
(Valenciennes 1827 –
Courbevoie 1875)

*Portrait of Princess Mathilde |
Portrait de la Princesse Mathilde*,
1862
black chalk with white highlights
on blue paper
30.9 × 18.6 cm
Paris, Musée d'Orsay (kept at
the Graphic Arts Department of
the Louvre), Gift of Prince
Georges Stirbey, 1888, RF 1308
Photo: © RMN / Thierry
Le Mage

*The Empress Eugénie Wearing a
Bonnet | L'Impératrice Eugénie en
bonnet*, c. 1870

black chalk with white highlights
on grey paper
15.7 × 11.8 cm
Paris, Musée d'Orsay (kept at
the Graphic Arts Department of
the Louvre), Gift of Prince
Georges Stirbey, 1888, RF 1312
Photo: © RMN (Musée d'Orsay) /
Jean-Gilles Berizzi

CARRIÈRE, Eugène
(Gournay, Seine-Saint-Denis
1849 – Paris 1906)

*Bust of a Woman in Frontal View,
One Hand Posed on Her Right
Cheek | Femme en buste, de face,
une main posée sur la joue droite*,
1895–1900
charcoal and stumping on paper
35.2 × 25.5 cm
Paris, Musée d'Orsay (kept at
the Graphic Arts Department of
the Louvre), RF 12905
Photo: © RMN (Musée d'Orsay) /
Jean-Gilles Berizzi

*Head of a Woman in Left Three-
Quarter View | Tête de femme, vue
de trois quarts à gauche*,
1895–1900
black Conté crayon with white
highlights on blue paper
40.8 × 29 cm
Paris, Musée d'Orsay (kept at
the Graphic Arts Department of
the Louvre), RF 15347
Photo: © RMN (Musée d'Orsay) /
Jean-Gilles Berizzi

CLAIRIN, Georges
(Paris 1843 – Belle-Île-en-Mer
1919)

*Portrait of Sarah Bernhardt
Reclining on a Couch | Portrait de
Sarah Bernhardt, à demi-étendue
sur un canapé*, 1876
watercolour and black Conté
crayon heightened with gouache
on paper
25.3 × 17.8 cm

Paris, Musée d'Orsay (kept at
the Graphic Arts Department of
the Louvre), Purchased 1980,
RF 38365
Photo: © RMN (Musée d'Orsay) /
Franck Raux

COTTET, Charles
(Le Puy 1863 – Paris 1925)

Head of a Girl | Tête de jeune fille,
c. 1890
pastel on paper
21 × 13.8 cm
Paris, Musée d'Orsay (kept at
the Graphic Arts Department of
the Louvre), RF 39303
Photo: © RMN (Musée d'Orsay) /
Michèle Bellot

COURBET, Gustave
(Ornans 1819 – La Tour-de-Peilz,
Switzerland 1877)

*Portrait of a Woman Surrounded by
Two Girls, One Holding a Lamb |
Portrait d'une femme entourée de
deux fillettes dont une qui tient un
agneau*, 1840
black Conté crayon and grey
wash on paper
22.6 × 30.1 cm
Paris, Musée d'Orsay (kept at
the Graphic Arts Department of
the Louvre), Gift of Ernest
Courbet, 1916, RF 36723
Photo: © RMN (Musée d'Orsay) /
Jean-Gilles Berizzi

*Portrait of the Artist's Young Sister
Juliet, Asleep | Portrait de sa sœur
Juliette Courbet enfant, dormant*,
1841
leadpoint on paper
20 × 26 cm
Paris, Musée d'Orsay (kept at
the Graphic Arts Department of
the Louvre), Gift of Ernest
Courbet, 1916, RF 4372
Photo: © RMN (Musée d'Orsay) /
Jean-Gilles Berizzi

Seated Woman Sleeping and Holding a Book, Right Hand Resting on a Table | *Femme assise, endormie, tenant un livre, la main droite sur la table*, 1849
charcoal and stumping with fixative on paper
47 × 30.6 cm
Paris, Musée d'Orsay (kept at the Graphic Arts Department of the Louvre), Purchased 1932, RF 22999
Photo: © RMN (Musée d'Orsay) / Michèle Bellot

DAUMIER, Honoré
(Marseille 1806 – Valmondois 1879)

Head of a Young Woman Leaning Forward, in Right Three-Quarter View | *Tête de jeune femme, penchée de trois quarts à droite*, 1830
black Conté crayon on paper
20.7 × 16.9 cm
Paris, Musée d'Orsay (kept at the Graphic Arts Department of the Louvre), Kœchlin bequest, 1931, RF 23297
Photo: © RMN (Musée d'Orsay) / Michèle Bellot

Two Sketches for a Ballerina | *Deux esquisses pour une danseuse*, 1849–50
leadpoint on paper
33.8 × 27.4 cm
Paris, Musée d'Orsay (kept at the Graphic Arts Department of the Louvre), Gift of the Amis du Louvre, 1923, RF 5897
Photo: © RMN (Musée d'Orsay) / Jean-Gilles Berizzi

The Defense Attorney | *Le Défenseur*, 1862–65
watercolour, pen and grey ink, grey wash, and black chalk, heightened with gouache, on paper
19 × 29.5 cm
Paris, Musée d'Orsay (kept at the Graphic Arts Department of

the Louvre), Dation, 1977, RF 36581
Photo: © RMN (Musée d'Orsay) / Michèle Bellot

DEGAS, Edgar
(Paris 1834 – Paris 1917)

Portrait of Hélène Hertel | *Portrait de Mademoiselle Hélène Hertel*, 1865
leadpoint on beige paper
27.5 × 19.7 cm
Paris, Musée d'Orsay (kept at the Graphic Arts Department of the Louvre), Bing bequest, 1922, RF 5604
Photo: © RMN (Musée d'Orsay) / Michèle Bellot

Twelve Studies for Women Dressed in Second Empire Style | *Douze études de femmes en costumes du second Empire*, 1866–68
ink and brush with white and coloured highlights on brown paper
46 × 32 cm
Paris, Musée d'Orsay (kept at the Graphic Arts Department of the Louvre), Bing bequest, 1922, RF 5602
Photo: © RMN (Musée d'Orsay) / Hervé Lewandowski

The End of the Arabesque (Dancer Bowing) | *Fin d'arabesque ou Danseuse saluant*, 1876–77
oil and pastel on canvas
65 × 36 cm
Paris, Musée d'Orsay, Isaac de Camondo bequest, 1908, RF 4040
Photo: © RMN (Musée d'Orsay) / Hervé Lewandowski

A Café on Boulevard de Montmartre | *Un café boulevard Montmartre*, 1877
pastel on paper
42 × 60 cm
Paris, Musée d'Orsay, Caillebotte bequest, 1894, RF 12257

Photo: © RMN (Musée d'Orsay) / Hervé Lewandowski

Bust of a Cabaret Singer | *Chanteuse de café-concert, en buste*, 1878
charcoal with white highlights on grey paper
47.3 × 30.5 cm
Paris, Musée d'Orsay (kept at the Graphic Arts Department of the Louvre), Purchased 1919, RF 4648
Photo: © RMN (Musée d'Orsay) / Franck Raux

Woman (Mary Cassatt) Tying the Ribbons of Her Hat | *Femme nouant les rubans de son chapeau, Mary Cassatt*, c. 1882
charcoal and pastel on beige paper
47.5 × 30.5 cm
Paris, Musée d'Orsay (kept at the Graphic Arts Department of the Louvre), Bing bequest, 1922, RF 5605
Photo: © RMN (Musée d'Orsay) / Jean-Gilles Berizzi

Standing Nude with Left Leg Raised, Foot Resting on a Base | *Femme nue debout, la jambe gauche levée, le pied sur un socle*, 1882–85
charcoal and pastel, squared, on blue vellum
49 × 30 cm
Paris, Musée d'Orsay (kept at the Graphic Arts Department of the Louvre), Purchased 1942, RF 29346
Photo: © RMN (Musée d'Orsay) / Hervé Lewandowski

Nude Seated on the Floor Combing Her Hair | *Femme nue, assise par terre, se peignant*, 1886–90
charcoal and pastel with pastel highlights on paper
55 × 67 cm
Paris, Musée d'Orsay (kept at the Graphic Arts Department of

the Louvre), Purchased 1968, RF 31840
Photo: © RMN (Musée d'Orsay) / Gérard Blot

Bather Drying Herself | *Baigneuse s'essuyant*, 1900–05
charcoal and pastel on beige paper
68 × 36 cm
Paris, Musée d'Orsay, Meyer donation, 2000, RF 52076
Photo: © RMN (Musée d'Orsay) / Michèle Bellot

DENIS, Maurice
(Granville 1870 – Saint-Germain-en-Laye 1943)

Nude Seen from Behind, Turned to the Right | *Femme nue, vue de dos, tournée vers la droite*, 1891
charcoal and pastel on paper
73 × 57 cm
Paris, Musée d'Orsay, Baron Christian bequest, RF 14915
Photo: © RMN (Musée d'Orsay) / Hervé Lewandowski

FANTIN-LATOUR, Henri
(Grenoble 1836 – Buré, Orne 1904)

Bust of a Woman Reading, in Three-Quarter View | *Femme en buste, de trois quarts, lisant*, 1861
charcoal on paper
35.8 × 32 cm
Paris, Musée d'Orsay (kept at the Graphic Arts Department of the Louvre), Purchased by the Musée du Luxembourg, Gift of Mme Fantin-Latour, RF 12248
Photo: © RMN (Musée d'Orsay) / Jean-Gilles Berizzi

Truth | *Vérité*, 1864
black chalk with stumping and charcoal on paper
29.9 × 37.8 cm
Paris, Musée d'Orsay (kept at the Graphic Arts Department of the Louvre), Gift of Mme Fantin-Latour, RF 12401

Photo: ©RMN (Musée d'Orsay) / Jean-Gilles Berizzi

FORAIN, Jean-Louis
(Reims 1852 – Paris 1931)

At the Nouvelle Athènes | Au café de la Nouvelle Athènes, 1885–90
watercolour, Indian ink, leadpoint, and brush on paper
36.2 × 39 cm
Paris, Musée d'Orsay (kept at the Graphic Arts Department of the Louvre), Carle Dreyfus bequest, 1953, RF 30038
Photo: ©RMN (Musée d'Orsay) / Jean-Gilles Berizzi

Young Woman Standing on a Balcony Contemplating the Paris Rooftops | Jeune femme debout sur un balcon, contemplant des toits parisiens, c.1890
watercolour, black Conté crayon, red chalk, and brush on paper
29 × 22.7 cm
Paris, Musée d'Orsay (kept at the Graphic Arts Department of the Louvre), Mr. Terris purchase, 1942, RF 29342
Photo: ©RMN (Musée d'Orsay) / Jean-Gilles Berizzi

GAUGUIN, Paul
(Paris 1848 – Atuona, Marquesas Islands 1903)

Study of Female Nudes, a Woman Bending Down, and Bust of a Woman Wearing a Hat | Étude de nus féminins, d'une femme courbée, d'un buste de femme chapeautée, c.1885
black Conté crayon on paper
30.9 × 23.9 cm
Paris, Musée d'Orsay (kept at the Graphic Arts Department of the Louvre), Purchased by the Musée du Luxembourg, RF 29877 2
Photo: ©RMN (Musée d'Orsay) / Jean-Gilles Berizzi

Bust: Study for a Woman's Head | Étude de tête de femme, vue en buste, 1886
leadpoint on paper
18.6 × 13.8 cm
Paris, Musée d'Orsay (kept at the Graphic Arts Department of the Louvre), RF 29877 24
Photo: ©RMN (Musée d'Orsay) / Jean-Gilles Berizzi

The Little Swineherd Seated, Knitting | La petite gardeuse de porcs assise tricotant, 1889
pastel on paper
83 × 48 cm
Paris, Musée d'Orsay (kept at the Graphic Arts Department of the Louvre), Gift of de Monfreid, 1968, RF 29898
Photo: ©RMN (Musée d'Orsay) / Gérard Blot

Seated Nude and Head Study | Femme nue assise et étude de tête, 1893
pen and brown ink, brown wash, and leadpoint, squared, on parchment
20 × 24.3 cm
Paris, Musée d'Orsay (kept at the Graphic Arts Department of the Louvre), Marcel Guiot Purchase, 1942, RF 29331
Photo: ©RMN (Musée d'Orsay) / Thierry Le Mage

Standing Nude with Figure Emerging from Behind a Tree | Femme nue debout, et derrière un arbre, émerge un personage, 1902
leadpoint on paper
22.5 × 21.5 cm
Paris, Musée d'Orsay (kept at the Graphic Arts Department of the Louvre), Marcel Guiot Purchase, 1942, RF 29332
Photo: ©RMN (Musée d'Orsay) / Jean-Gilles Berizzi

GUILLAUMIN, Armand
(Paris 1841 – Orly, Val-d'Oise 1927)

Portrait of a Little Girl with Red Hair | Portrait de fillette aux cheveux roux, 1894
pastel on paper
45.5 × 55 cm
Paris, Musée d'Orsay (kept at the Graphic Arts Department of the Louvre), Purchased by the Musée du Luxembourg, 1916, RF 12837
Photo: ©RMN (Musée d'Orsay) / Hervé Lewandowski

GUYS, Constantin
(Vlissingen, The Netherlands 1802 – Paris 1892)

Young Woman with Her Chaperone | Jeune femme et sa Duègne, c.1860
watercolour, black Conté crayon, pen and brown ink, and brown wash on paper
26.5 × 22 cm
Paris, Musée d'Orsay (kept at the Graphic Arts Department of the Louvre), Purchased 1942, RF 29334
Photo: ©RMN (Musée d'Orsay) / Michèle Bellot

HELLEU, Paul
(Vannes, Morbihan 1859 – Paris 1927)

Woman Leaning on a Table | Femme accoudée à une table, 1889
pastel on buff-coloured paper
100 × 49.6 cm
Paris, Musée d'Orsay (kept at the Graphic Arts Department of the Louvre), Gift of Mme Howard Johnston, née Helleu, 1986, RF 38811
Photo: ©RMN (Musée d'Orsay) / Hervé Lewandowski

Paulette Sitting in a Chair, Seen from Behind | Paulette, assise sur une chaise, de dos, 1903

black Conté crayon and red chalk with white highlights on paper
63 × 46.5 cm
Paris, Musée d'Orsay (kept at the Graphic Arts Department of the Louvre), Gift of Mme Howard Johnston, née Helleu, 1986, RF 41280
Photo: ©RMN (Musée d'Orsay) / Hervé Lewandowski

JEANNIOT, Pierre-Georges
(Geneva, Switzerland 1848 – Paris 1934)

Woman Combing Her Hair | Femme se peignant, 1890–92
pastel on paper
58 × 46 cm
Paris, Musée d'Orsay, Noufflard donation, 1989, RF 41657
Photo: ©RMN (Musée d'Orsay) / Hervé Lewandowski

LEGROS, Alphonse
(Dijon 1837 – Watford, UK 1911)

Half-length Portrait of a Little Girl Holding a Doll | Petite fille, à mi-corps, tenant une poupée, c.1870
leadpoint on paper
26.8 × 22.5 cm
Paris, Musée d'Orsay (kept at the Graphic Arts Department of the Louvre), Brandon donation, 1897, RF 15889
Photo: ©RMN (Musée d'Orsay) / Thierry Le Mage

MAILLOL, Aristide
(Banyuls-sur-Mer 1861 – Perpignan 1944)

Two Nudes, One Frontal, the Other from Behind | Deux femmes nues, l'une de face, l'autre de dos, 1937
charcoal with white highlights on cream-coloured paper
112 × 95.4 cm

Paris, Musée d'Orsay (kept at the Graphic Arts Department of the Louvre), Hirsh donation, 1976, RF 36168
Photo: © RMN (Musée d'Orsay) / Jean-Gilles Berizzi

MANET, Édouard
(Paris 1832 – Paris 1883)

Portrait of Nina de Villard (Madame Callias) | Portrait de Nina de Villard, Mme Callias, 1873–74
gouache heightened with leadpoint on wood
9.5 × 7 cm
Paris, Musée d'Orsay (kept at the Graphic Arts Department of the Louvre), Rosenthal donation, 1920, RF 5177
Photo: © RMN (Musée d'Orsay) / Michèle Bellot

MÉNARD, Émile-René
(Paris 1862 – Paris 1930)

Study of a Nude in an Interior | Étude de nu dans un intérieur, c. 1890
pastel on paper
61 × 79.5 cm
Paris, Musée d'Orsay, RF 39722
Photo: © RMN (Musée d'Orsay) / Hervé Lewandowski

MERSON, Luc-Olivier
(Paris 1845 – Paris 1920)

Standing Young Nude in Right Three-Quarter View | Jeune fille nue, debout, de trois quarts vers la droite, c. 1900
red and black chalk with white highlights on paper, pricked for transfer
60 × 31.6 cm
Paris, Musée d'Orsay (kept at the Graphic Arts Department of the Louvre), Gift of Paul Adolphe, RF 14987
Photo: © RMN (Musée d'Orsay) / Jean-Gilles Berizzi

MILLET, Jean-François
(Gruchy, near Cherbourg 1815 – Barbizon 1875)

Bust of a Young Nude | Buste de jeune fille nue, 1849–50
charcoal on paper
19.9 × 16.4 cm
Paris, Musée d'Orsay (kept at the Graphic Arts Department of the Louvre), Gift of Walter Gay, 1938, RF 4183
Photo: © RMN (Musée d'Orsay) / Thierry Le Mage

The Gleaners | Les Glaneuses, 1850–51
black Conté crayon on beige paper
16.5 × 26.7 cm
Paris, Musée d'Orsay (kept at the Graphic Arts Department of the Louvre), Sancholle-Henraux bequest, 1953, RF 30571
Photo: © RMN (Musée d'Orsay) / Thierry Le Mage

Seated Shepherdess Wearing a Cloak, Right Hand Holding a Staff | Bergère assise, couverte d'un manteau, un bâton dans la main droite, 1851–52
charcoal on beige paper
29 × 20 cm
Paris, Musée d'Orsay (kept at the Graphic Arts Department of the Louvre), Purchase of the Direction des Beaux-Arts, 1875, RF 244
Photo: © RMN (Musée d'Orsay) / Thierry Le Mage

MORISOT, Berthe
(Bourges 1841 – Paris 1905)

Portrait of Madame Pillaut | Portrait de Madame Pillaut, 1866
watercolour and leadpoint on paper
30.5 × 20.5 cm
Paris, Musée d'Orsay (kept at the Graphic Arts Department of

the Louvre), Gift of Mme Julien Pillaut, 1958, RF 31284
Photo: © RMN (Musée d'Orsay) / Gérard Blot

Half-Nude Woman Fixing Her Hair, Seen from Behind, Her Body Reflected in a Mirror | Femme demi-nue, vue de dos, se coiffant, une glace reflétant son corps, 1891
leadpoint on tracing paper
30.5 × 20.7 cm
Paris, Musée d'Orsay (kept at the Graphic Arts Department of the Louvre), RF 12006
Photo: © RMN / Jean-Gilles Berizzi

PISSARRO, Camille
(Saint-Thomas, former Danish West Indies 1830 – Paris 1903)

Kneeling Peasant Woman Seen from Behind | Paysanne à genoux, vue de dos, 1870
charcoal and stumping on cream-coloured paper
61.5 × 46 cm
Paris, Musée d'Orsay (kept at the Graphic Arts Department of the Louvre), Purchased 1947, RF 29535
Photo: © RMN (Musée d'Orsay) / Jean-Gilles Berizzi

Bust of an Old Woman Knitting | Vieille femme en buste tricotant, c. 1878
black chalk on paper
29 × 23 cm
Paris, Musée d'Orsay (kept at the Graphic Arts Department of the Louvre), Purchased by the Musées Nationaux, 1947, RF 29529
Photo: © RMN (Musée d'Orsay) / Jean-Gilles Berizzi

Harvesting Peas | La cueillette des pois, 1885
watercolour and black Conté crayon on paper
21.5 × 17 cm

Paris, Musée d'Orsay (kept at the Graphic Arts Department of the Louvre), Carle Dreyfus bequest, 1953, RF 30099
Photo: © RMN (Musée d'Orsay) / Michèle Bellot

Study for Two Women Chatting | Étude pour la causette, 1892
charcoal, red chalk, and red pencil on beige paper
60 × 37 cm
Paris, Musée d'Orsay (kept at the Graphic Arts Department of the Louvre), Purchased 1947, RF 29534
Photo: © RMN (Musée d'Orsay) / Michèle Bellot

Group of Bathers at Water's Edge | Groupe de baigneuses au bord de l'eau, 1894–96
gouache and pencil on silk with paper backing
25.6 × 21.7 cm
Paris, Musée d'Orsay (kept at the Graphic Arts Department of the Louvre), Purchased from Édouard Petit, 1931, RF 16726
Photo: © RMN (Musée d'Orsay) / Jean-Gilles Berizzi

Market in Gisors | Marché de Gisors, 1895
etching and blue watercolour on paper
19.6 × 18.7 cm
Paris, Musée d'Orsay (kept at the Graphic Arts Department of the Louvre), Carle Dreyfus bequest, 1953, RF 30106
Photo: © RMN / Michèle Bellot

PUVIS DE CHAVANNES, Pierre
(Lyon 1824 – Paris 1898)

Nude Seen from Behind, Left Arm Extended, and Sketch of Her Head | Femme nue, vue de dos, le bras gauche tendu, et reprise de la tête, 1878–80

black Conté crayon and stumping, squared, on beige paper
26.6 × 17.7 cm
Paris, Musée d'Orsay (kept at the Graphic Arts Department of the Louvre), Gift of the heirs of Puvis de Chavannes, 1899, RF 2183
Photo: © RMN (Musée d'Orsay) / Thierry Le Mage

Woman Brushing a Seated Woman's Hair / Une femme coiffant une femme assise, 1883
black Conté crayon with white highlights on paper
31.4 × 24 cm
Paris, Musée d'Orsay (kept at the Graphic Arts Department of the Louvre), Purchased 1938, RF 29111
Photo: © RMN (Musée d'Orsay) / Michèle Bellot

REDON, Odilon
(Bordeaux 1840 – Paris 1916)

Madame Redon Embroidering, in Profile / Portrait de Madame Redon brodant, vue de profil, 1880
pastel on paper
58 × 42 cm
Paris, Musée d'Orsay (kept at the Graphic Arts Department of the Louvre), Gift of Ari and Suzanne Redon, 1982, RF 40490
Photo: © RMN (Musée d'Orsay) / Hervé Lewandowski

Profile of a Veiled Woman (Profile in Light) / Profil de lumière : profil de femme voilée, c.1885
charcoal on buff-coloured paper
38.8 × 28.9 cm
Paris, Musée d'Orsay (kept at the Graphic Arts Department of the Louvre), Gift of Mme René Asselin, 1978, RF 36816
Photo: © RMN (Musée d'Orsay) / Gérard Blot

REGNAULT, Henri
(Paris 1843 – Buzenval 1871)

Woman of Madrid (The Countess de Barck Seen from Behind) / La Madrilène, Comtesse de Barck, vue de dos, 1869
watercolour, black ink, and leadpoint on paper
46 × 29.5 cm
Paris, Musée d'Orsay (kept at the Graphic Arts Department of the Louvre), RF 10
Photo: © RMN (Musée d'Orsay) / Thierry Le Mage

RENOIR, Pierre-Auguste
(Limoges 1841 – Cagnes-sur-Mer 1919)

Woman Seated in an Interior, Surrounded by Figures / Femme assise dans un intérieur, entourée de personnages, c.1875
pen and brown ink on paper
13.5 × 10.4 cm each
Paris, Musée d'Orsay (kept at the Graphic Arts Department of the Louvre), Gift of the Amis du Louvre, 1934, RF 24224, RF 24225, RF 24226
Photo: © RMN (Musée d'Orsay) / Thierry Le Mage

The Country Dance / La Danse à la campagne, 1882
black Conté crayon on paper
24.5 × 12.3 cm
Paris, Musée d'Orsay (kept at the Graphic Arts Department of the Louvre), César Mange de Hauke bequest, 1965, RF 31717
Photo: © RMN (Musée d'Orsay) / Jean-Gilles Berizzi

Seated Bather Drying Her Arms / Baigneuse assise s'essuyant les bras, 1887
watercolour and leadpoint with white highlights on brown paper
49 × 30 cm

Paris, Musée d'Orsay (kept at the Graphic Arts Department of the Louvre), Purchased 1940, RF 29345
Photo: © RMN (Musée d'Orsay)

Bust of a Little Girl Wearing a Large Mob Cap / Portrait de fillette en buste portant une vaste charlotte, 1900–06
pastel on paper
53.1 × 42.7 cm
Paris, Musée d'Orsay, Gift of Mme Albert Charpentier, 1951, RF 29899
Photo: © RMN (Musée d'Orsay) / Hervé Lewandowski

RODIN, Auguste
(Paris 1840 – Meudon 1917)

Woman Lying on Her Stomach, Seen from Behind / Femme nue, de dos, étendue sur le ventre, 1896–1900
leadpoint and watercolour on paper
32.5 × 24.5 cm
Paris, Musée d'Orsay (kept at the Graphic Arts Department of the Louvre), Rivière bequest, 1954, RF 29942
Photo: © RMN (Musée d'Orsay) / Jean-Gilles Berizzi

Female Nude Reclining on Her Back / Nu féminin, étendu sur le dos, 1896–1916
watercolour and leadpoint on beige paper
25.6 × 33.5 cm
Paris, Musée d'Orsay (kept at the Graphic Arts Department of the Louvre), Gift of Mme René Asselain, 1978, RF 36818
Photo: © RMN (Musée d'Orsay) / Gérard Blot

Nude Wearing a Brown Jacket / Femme nue, portant une veste brune, c.1905

leadpoint and watercolour on beige paper
32 × 25 cm
Paris, Musée d'Orsay (kept at the Graphic Arts Department of the Louvre), Rivière bequest, 1954, RF 29942 bis
Photo: © RMN / Jean-Gilles Berizzi

SCHUFFENECKER, Émile
(Fresne-Saint-Mamès 1851 – Paris 1934)

Portrait of Mademoiselle Fontalirand / Portrait de Mademoiselle Fontalirand, 1894
black chalk and pastel on paper
47.5 × 30.5 cm
Paris, Musée d'Orsay (kept at the Graphic Arts Department of the Louvre), Purchased 1978, RF 36829
Photo: © RMN (Musée d'Orsay) / Jean-Gilles Berizzi

SEURAT, Georges
(Paris 1859 – Paris 1891)

Seated Nursemaid Holding Her Infant / Nourrice assise, tenant son poupon, 1881–82
charcoal on paper
32.8 × 25.5 cm
Paris, Musée d'Orsay (kept at the Graphic Arts Department of the Louvre), Paul Jamot bequest, 1939, RF 29302
Photo: © RMN (Musée d'Orsay) / Michèle Bellot

The Black Bow / Le nœud noir, c.1882
Conté crayon on paper
31 × 23 cm
Paris, Musée d'Orsay (kept at the Graphic Arts Department of the Louvre), Acquisition 1989, RF 41903
Photo: © RMN (Musée d'Orsay) / Gérard Blot

At the Balcony / Devant le balcon,
1883
Conté crayon on white paper
31.5 × 24.6 cm
Paris, Musée d'Orsay (kept at
the Graphic Arts Department of
the Louvre), Gift of C. Pissarro,
1904, RF 29548
Photo: © RMN (Musée d'Orsay) /
Michèle Bellot

TOULOUSE-LAUTREC, Henri de
(Albi 1864 – Château de
Malromé, Gironde 1901)

*Réjane Wearing a Riding Hat in
"Madame Sans-Gêne" / Réjane,
coiffée d'un chapeau d'amazone,
dans « Madame Sans-Gêne »*,
1893
leadpoint on paper
16.3 × 9.4 cm
Paris, Musée d'Orsay (kept at
the Graphic Arts Department of
the Louvre), Gift of the Amis
du Louvre, 1947, RF 29568
Photo: © RMN (Musée d'Orsay) /
Jean-Gilles Berizzi

*The Milliner (Mademoiselle Le
Margouin at Madame Renée Vert's) /
La Modiste : mademoiselle Le
Margouin chez madame Renée
Vert*, 1893
pen and brown ink and leadpoint
on paper
17 × 10.8 cm
Paris, Musée d'Orsay (kept at
the Graphic Arts Department of
the Louvre), Purchased 1947,
RF 29587

Photo: © RMN (Musée d'Orsay) /
Jean-Gilles Berizzi

*Two Women Sitting in a Café /
Deux femmes assises au café*, 1893
watercolour and leadpoint on
tracing paper and cardboard
53.8 × 37.9 cm
Paris, Musée d'Orsay (kept at
the Graphic Arts Department of
the Louvre), Gift of Roger Marx,
RF 29550
Photo: © RMN (Musée d'Orsay) /
Thierry Le Mage

*Blonde Madam / Femme de
maison blonde*, 1894
oil on cardboard
68 × 48 cm
Paris, Musée d'Orsay, Gift 1930,
RF 1943-65
Photo: © RMN (Musée d'Orsay) /
Hervé Lewandowski

*Yvette Guilbert, Arms Fallen to Her
Sides / Yvette Guilbert, les deux
bras tombant le long du corps*, 1894
leadpoint on tracing paper
21.5 × 8.8 cm
Paris, Musée d'Orsay (kept at
the Graphic Arts Department of
the Louvre), Gift of the Amis
du Louvre, 1947, RF 29572
Photo: © RMN (Musée d'Orsay) /
Thierry Le Mage

*Head of a Woman in Left Three-
Quarter View / Tête de femme, vue
de trois quarts à gauche*, c. 1896
red chalk on gray cardboard
54.6 × 36 cm

Paris, Musée d'Orsay (kept at
the Graphic Arts Department of
the Louvre), Berthellemy
donation, 1943, RF 29431
Photo: © RMN (Musée d'Orsay) /
Thierry Le Mage

VALLOTTON, Félix Édouard
(Lausanne, Switzerland 1865 –
Paris 1925)

*Intimacy: Surprise / Les intimités :
La surprise*, 1897
pen and ink, Indian ink wash,
and leadpoint on paper
20.7 × 26 cm
Paris, Musée d'Orsay (kept at
the Graphic Arts Department of
the Louvre), RF 40205
Photo: © RMN (Musée d'Orsay) /
Thierry Le Mage

*Initmacy: The Lie / Les intimités :
Le mensonge*, 1897
Pen and ink, Indian ink wash,
and leadpoint on paper
20.7 × 26 cm
Paris, Musée d'Orsay (kept at
the Graphic Arts Department of
the Louvre), RF 40210
Photo: © RMN (Musée d'Orsay) /
Thierry Le Mage

*Intimacy: Dressing to Go Out /
Les intimités : La toilette de sortie*,
1897–98
pen and ink, Indian ink wash,
and leadpoint on paper
20.7 × 26 cm
Paris, Musée d'Orsay (kept at
the Graphic Arts Department of
the Louvre), RF 40214

Photo: © RMN (Musée d'Orsay) /
Thierry Le Mage

VUILLARD, Édouard
(Cuiseaux, Saône-et-Loire 1868 –
La Baule 1940)

*Woman Sitting in a Bar / Femme
assise dans un bar*, 1893–94
watercolour and gouache on
paper
20.3 × 13.9 cm
Paris, Musée d'Orsay (kept at
the Graphic Arts Department of
the Louvre), Gift of Mme René
Asselain, 1978, RF 36821
Photo: © RMN (Musée d'Orsay) /
Gérard Blot

*Seated Nude Model, Seen from
Behind / Modèle féminin nu, assis
de dos*, c. 1900
charcoal and stumping on paper
53.5 × 40.4 cm
Paris, Musée d'Orsay (kept at
the Graphic Arts Department of
the Louvre), Gift of Mme K.X.
Roussel, 1941, RF 40238
Photo: © RMN (Musée d'Orsay) /
Michèle Bellot

*Portrait of the Countess Anna de
Noailles / Portrait de la Comtesse
Anna de Noailles*, 1931
charcoal on canvas
110 × 126 cm
Paris, Musée d'Orsay (kept at
the Graphic Arts Department of
the Louvre), RF 40334
Photo: © RMN (Musée d'Orsay) /
Jean-Gilles Berizzi

ACKNOWLEDGEMENTS

This exhibition is the result of the passion and professionalism of scores of people who were involved in its making. For *The Modern Woman*, we would first like to extend our profound gratitude to Kathleen Bartels, Director of the Vancouver Art Gallery, and Guy Cogeval, Président du Musée d'Orsay, for their tremendous support and enthusiasm for this project. We are also thankful to Carel Van Tuyll, Directeur du département des arts graphiques at the Musée du Louvre, whose generous cooperation was essential to the exhibition.

At the Vancouver Art Gallery, we extend our gratitude to the entire staff, who contributed expertise and remarkable energy to the realization of this exhibition. We thank Daina Augaitis, Chief Curator/Associate Director, for her constant encouragement and guidance regarding the exhibition and catalogue. We would also like to recognize Paul Larocque, Associate Director, who provided much appreciated advice and assistance. Kathleen Ritter, Assistant Curator, contributed immeasurably to the exhibition, overseeing all aspects of the exhibition design process and deftly coordinating its installation; we are deeply indebted to her for this significant effort. With particular nuance, Kimberly Phillips, Program Coordinator, developed the interpretive materials that allow greater understanding of these drawings. Jenny Wilson, Registrar, adeptly managed the complexities of travelling the loans. We extend our thanks to Chris Nichols and the Finance/Administration staff; Tom Meighan and the Security/Visitor Services staff; Jessica Bouchard and the Development department; Dana Sullivant, Andrew Riley and the Marketing staff; Heidi Reitmaier and the Public Programs staff; Trevor Mills and Danielle Currie in Photo Imaging; Glen Flanderka, Rory Gylander and all the members of the installation team; Monica Smith and the conservators; and Wade Thomas, Susan Perrigo and the Audio Visual staff. In the Curatorial department, we also wish to thank Bruce Wiedrick for his astute administrative management, and Angela Mah and Suzanne Hepburn for their essential support. Finally, we extend our appreciation to Darren Carcary and Kirsti Wakelin of Resolve Design, Inc., whose formidable talent resulted in their fresh exhibition installation design — a superb background against which the beauty of these drawings are fully appreciated.

At the Musée d'Orsay we have benefitted enormously from a highly talented group of individuals, all of whom have contributed immensely to this project. We greatly appreciate the dedication of Olivier Simmat, Chef de Cabinet du Président, Mecenat et Relations Internationales, who provided valuable assistance from the very earliest stages of the project. We wish to extend our thanks to Jean Naudin, Conservation, responsable des expositions internationales, who diligently and with great professionalism coordinated all administrative aspects of the project, abundantly assisted by Denis Thibaud, Juriste, au secteur des affaires financièrs et juridiques. We extend our sincere appreciation to Thierry Gausseron, Administrateur général; Hélène Flon, Chef du service des expositions; and Anne Meny-Horn, Administrateur adjoint, as well as Elsa Badie-Modiri, Stéphane Bayard, Annie Dufour, Isabelle Gaëtan, Christian Garoscio, Dominique Lobstein, Caroline Mathieu, Odile Michel, Delphine Peschard, Anne Roquebert, Marie-Pierre Salé, Philippe Saunier, Laurent Stanich and Alice Thomine-Berrada. At the Musée du Louvre, we wish to express our

appreciation to Valerie Corvino, Clarine Guillou, Irène Julier and Anna di Pietra for their kind cooperation. And finally, to the Réunion des Musées Nationaux (RMN) team, we extend our thanks for their spirit of cooperation on the exhibition, in particular for their assistance with photographic services.

We would like to acknowledge all of those who participated in the production of this catalogue. First and foremost, Karen Love, Manager of Curatorial Affairs at the Vancouver Art Gallery, led the team of people involved in its publication with her usual consummate skill, good cheer and grace under pressure. We are deeply appreciative of her contribution and her expertise. Mark Polizzotti translated and edited Isabelle Julia's text with great sensitivity and insight. Lana Okerlund's copyediting skills were truly appreciated. Lastly, we thank Mark Timmings for his elegant catalogue design, which perfectly complements the extraordinary drawings assembled here.

To all of these individuals, we offer our profound thanks.

Thomas Padon, Assistant Director / Director of International Partnerships, Vancouver Art Gallery

Isabelle Julia, Conservateur général du Patrimoine, Arts Graphiques, Musée d'Orsay

Published in conjunction with *The Modern Woman: Drawings by Degas, Renoir, Toulouse-Lautrec and Other Masterpieces from the Musée d'Orsay, Paris*, an exhibition organized by the Vancouver Art Gallery and the Musée d'Orsay and presented in Vancouver from June 5 to September 6, 2010.

Publication Coordinator: Karen Love

Copyeditor: Lana Okerlund

Translator/Editor, French to English: Mark Polizzotti

Designer: Mark Timmings, Timmings & Debay

Digital Image Preparation: Trevor Mills, Vancouver Art Gallery

Printed and bound in Canada by Generation Printing

Presenting Sponsor:

Maynards SINCE 1902

Major Sponsor:

CONCORD PACIFIC

Supporting Sponsor: Scotiabank

Supported by the Canada Travelling Exhibitions Indemnification Program of the Department of Canadian Heritage, with additional assistance from the Consulat général du France, Vancouver

LIBRARY AND ARCHIVES CANADA CATALOGUING IN PUBLICATION

The modern woman : drawings by Degas, Renoir, Toulouse-Lautrec and other masterpieces from the Musée d'Orsay, Paris / exhibition commissioners, Guy Cogeval, Isabelle Julia and Thomas Padon ; curator, Isabelle Julia.

Co-published by the Musée d'Orsay.

Catalogue of an exhibition held at the Vancouver Art Gallery from June 6 to Sept. 6, 2010.

ISBN 978-1-895442-81-6

1. Women in art — Exhibitions. 2. Drawing, French — Exhibitions. 3. Drawing — France — Paris — Exhibitions. 4. Musée d'Orsay — Exhibitions.

I. Julia, Isabelle II. Cogeval, Guy III. Padon, Thomas IV. Musée d'Orsay V. Vancouver Art Gallery

N7629.2.C3V36 2010 741.944074'71133

C2010-902292-0

IMAGE CREDITS

Cover: Edgar Degas, *A Café on Boulevard de Montmartre / Un café boulevard Montmartre*, 1877 (detail)

Title page: Edmond-François Aman-Jean, *Bust of a Woman Turned to the Left, Chin Resting on Her Hand / Femme, vue en buste, tournée vers la gauche, appuyant son menton sur sa main*, 1906

The Vancouver Art Gallery is a not-for-profit organization supported by its members; individual donors; corporate funders; foundations; the City of Vancouver; the Province of British Columbia through the British Columbia Arts Council and Gaming Revenues; the Canada Council for the Arts; and the Government of Canada through the Department of Canadian Heritage.

VANCOUVER ART GALLERY

750 Hornby Street
Vancouver, BC Canada V6Z 2H7
www.vanartgallery.bc.ca

MUSÉE D'ORSAY

62, rue de Lille
75343 Paris cedex 07 France
www.musee-orsay.fr